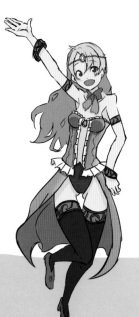

HOW TO CREATE
MANGA

THE ULTIMATE BIBLE FOR BEGINNING ARTISTS

DRAWING ACTION SCENES AND CHARACTERS

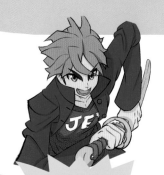

With Over
650
Illustrations

SHIKATA SHIYOMI

TUTTLE Publishing

Tokyo | Rutland, Vermont | Singapore

Contents

Why I Wrote This Book 5

How to Use This Book 6

PART 1 Building Action Scenes

Low-Angle Views
8

Aerial or Bird's-Eye Views
12

Main Characters
16

Main Objects
18

Composing from Eye Level
20

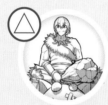

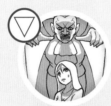

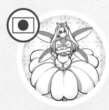

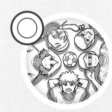

Diagonal Compositions
22

Triangle Compositions
26

Inverted Triangle Compositions
30

Hinomaru Compositions
34

Circle Compositions
38

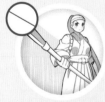

Diagonal Line Compositions
42

Two-Part or Split Compositions
46

Three-Part Compositions
50

Margin Compositions
54

Frame Compositions
58

Panel Compositions
62

Alphabet Compositions
66

Z Compositions
70

The Golden Ratio
74

Overlapping Compositions
78

Cut-Up Compositions
82

Close-Ups
86

Medium Close-Ups
90

Medium Shots
94

Medium Long Shots
98

Full-Body Shots
102

Two Shots
106

Three Shots
110

Group Shots
114

PART 2 Drawing Action Characters

Contrapposto
120

S Poses
124

Overperspective
130

Silhouettes
134

Balance and Center of Gravity
138

Hair and Clothes
142

Emotions
146

Facial Expressions
150

Action and Motion
154

Special Moves
158

Fantasy Poses
162

Appendices

How to Draw Muscles **166**

How to Create Data **171**

Index **175**

How to Use This Book

A Two-Part Approach

This book explains the mind-blowing effects you can achieve when using different composition and posing methods. We'll cover the basic skills you'll need to develop the style that suits you best, as well as practical ways of using dramatic poses and eye-catching and multilayered compositions to fill the frame and make your story as dynamic and compelling as possible.

"Part 1: Building the Action" explains triangle composition, circle composition, diagonal composition and other approaches that put you in the director's chair for your digital manga creations. You'll also learn how to combine your skills for one-shot, two-shot and group-shot scenes or for capturing that one powerful pose or key moment your story hinges on.

"Part 2: Action Poses" introduces notions of contraposing and S posing, the range of practical techniques and approaches that infuse your digital illustrations with movement, motion and action.

Page Set-up

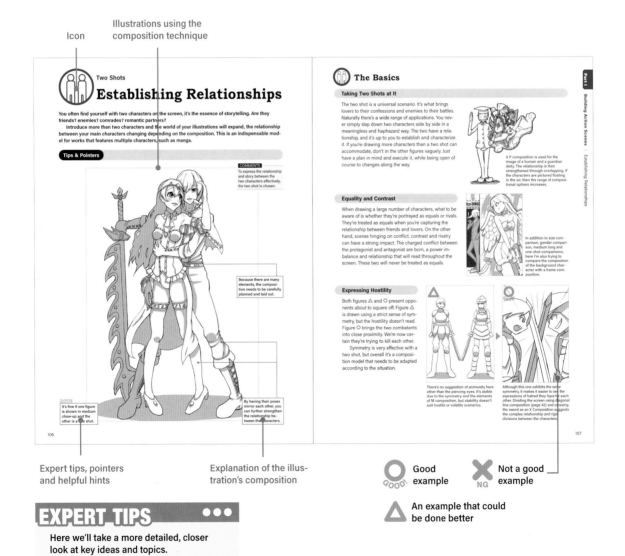

Icon

Illustrations using the composition technique

Expert tips, pointers and helpful hints

Explanation of the illustration's composition

Good example — Good example

Not a good example — Not a good example

An example that could be done better

EXPERT TIPS ●●●

Here we'll take a more detailed, closer look at key ideas and topics.

PART 1

Building Action Scenes

Low-Angle Views

Aerial or Bird's-Eye Views

Main Characters

Main Objects

Composing from Eye Level

Diagonal Compositions

Triangle Compositions

Inverted Triangle Compositions

Hinomaru Compositions

Circle Compositions

Diagonal Line Compositions

Two-Part or Split Compositions

Three-Part Compositions

Margin Compositions

Frame Compositions

Panel Compositions

Alphabet Compositions

Z Compositions

The Golden Ratio

Overlapping Compositions

Cropping and Trimming

Close-Ups

Medium Close-Ups

Medium Shots

Medium Long Shots

Full-Body Shots

Two Shots

Three Shots

Group Shots

Composition That Highlights Intensity

Low-Angle Views

Tilting is the composition method where your characters are being seen or viewed from a low angle. It adds height and dimension as well as allowing for more compressed intensity. Even used selectively within illustrations, it allows you to create more compact action.

Tilting is not usually used for images showing only one character, such as the sketches and treatments created during the character-design phase. This method is also ideal for comparing characters; thus it can be used in conjunction with the two-shot method (page 106).

Tips & Pointers

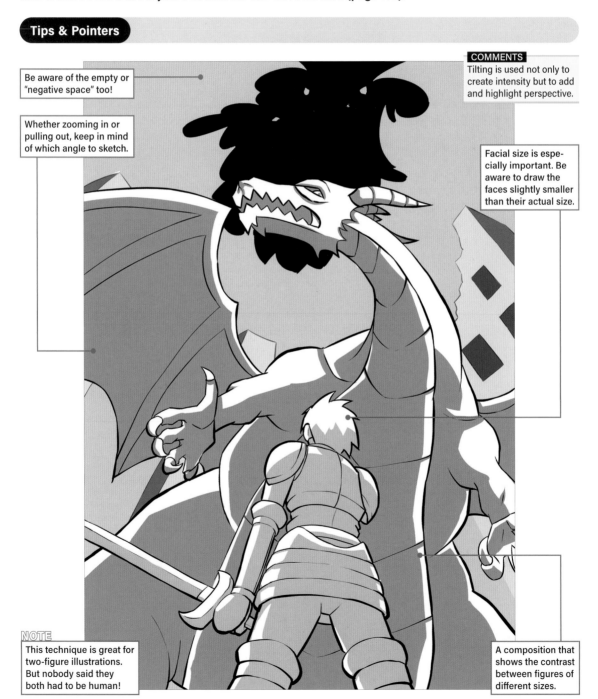

Be aware of the empty or "negative space" too!

Whether zooming in or pulling out, keep in mind of which angle to sketch.

COMMENTS
Tilting is used not only to create intensity but to add and highlight perspective.

Facial size is especially important. Be aware to draw the faces slightly smaller than their actual size.

NOTE
This technique is great for two-figure illustrations. But nobody said they both had to be human!

A composition that shows the contrast between figures of different sizes.

The Basics

Viewed from Below

This composition technique allows you to sketch while viewing your scene from below. Since it involves the use of perspective, the image's upper part is drawn smaller, while the lower part is enlarged." Foregrounding the bottom of the illustration and having the character looking down at the viewer add intensity and immediacy to the drawing.

Since tilting is a composition method ideal for showing heights, a vertical orientation to the illustration works best.

Since the vanishing point is at the top of the image, tilting pairs nicely with Triangle Composition (page 26), used frequently to give your illustration stability. Also, for people who find tilting and the bird's-eye view method still somewhat hard to use, try the box sketching method instead.

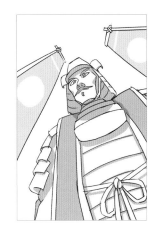

Understanding Solidity and Muscles

For beginners, tilting is a composition method that can be a bit tricky. Because tilting is tied so closely to perspective, it's essential to have a strong sense of solidity to effectively use this approach.

There's a sketching method, referred to as box sketching, in which different parts of a body, like the face or the torso, are overlapped. It's an effective substitute or alternate course when tilting proves difficult to use.

Use box sketching to sketch a rough tilt image. It doesn't have to be strictly a cube, but keep the image roughly in that shape.

A character is completed, based on the rough tilted sketch, through box sketching.

Understanding muscles is key to this approach and will make sketching them much easier. Don't familiarize yourself with only the muscles that stand out. It's far better to understand the entire form before attempting to sketch it.

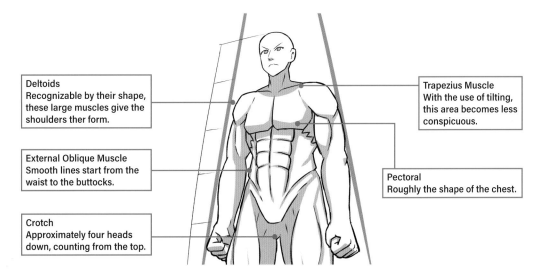

Deltoids
Recognizable by their shape, these large muscles give the shoulders ther form.

External Oblique Muscle
Smooth lines start from the waist to the buttocks.

Crotch
Approximately four heads down, counting from the top.

Trapezius Muscle
With the use of tilting, this area becomes less conspicuous.

Pectoral
Roughly the shape of the chest.

9

Considering the Size of the Face

The image with △ is sketched using the tilting method, yet with a rather oversized face. The tilting method often makes the face look bigger than it would typically be. Colorizing will eventually make the face's size stand out even in the rough-sketch stage.

Sketching a tilted face usually requires several drafts and revisions in order to achieve the right balance. If you want to make the faces bigger, use digital techniques to adjust your sketched characters' faces.

As the face is the most significant part of the body, sketch it with care, taking the time to render it right.

Refer to page 13 for facial sketching skills.

The figure's more to the foreground, the face farther from the waist and too large: a facial fail!

Here balance is achieved by reducing the size of the face and enhancing the power of the overall illustration.

Emotional Intensity and Clarity

Be aware of the viewer's or camera's position when using the tilting method.

Although tilting is a composition method that gives a character a strong presence and a more pronounced impact, pay particular attention to the extent to which you want to sketch in the background. For example, in illustrations showing a significant amount of background, stretch far from the character's view ❶. Reducing the size of the character's face and increasing the distance from the viewer/camera diminishes the emotional intensity.

On the opposite side, to reinforce the character's emotions or for a necessary note of added clarity, a close-up sketch is far better ❷.

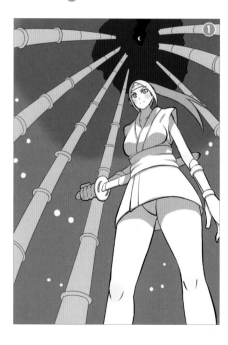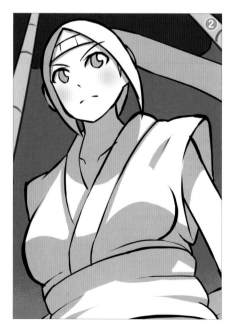

Let's Get Practical

Visual Comparisons

Tilting is especially suited for comparing sizes or highlighting the size difference in two or more characters.

By sketching both large and small motifs in the same image, the differences in the sizes of each are easier to establish. The technique allows you to highlight each element's individuality as well.

For example, a teenage boy and a gigantic robot or a maiden and a warrior: These are motifs involving different figures and body sizes. They're sketched with an eye to comparison and attention to physical relationship, and can be drawn a bit larger without offsetting the balance.

Modeling the Method

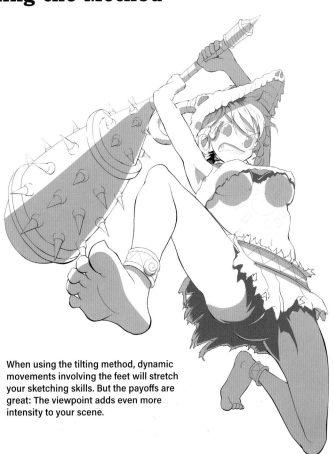

When using the tilting method, dynamic movements involving the feet will stretch your sketching skills. But the payoffs are great: The viewpoint adds even more intensity to your scene.

Compositions That Offer Overhead Views

Aerial or Bird's-Eye Views

The high-angle or bird's-eye view is the composition technique that allows your illustration to be viewed from above or from an elevated position or high perspective, while allowing details to be included. Increasing the facial size, depending on the needs of the scene, can highlight and intensify the character's affability and cuteness.

Like the tilting method (page 8), this approach is not frequently used for character design. It's a method best used for capturing the details of a character or for events in your story with special meaning. Remember to use tilting and the bird's-eye or high-angle view approaches as a pair or use them separately depend on your illustration needs.

Tips & Pointers

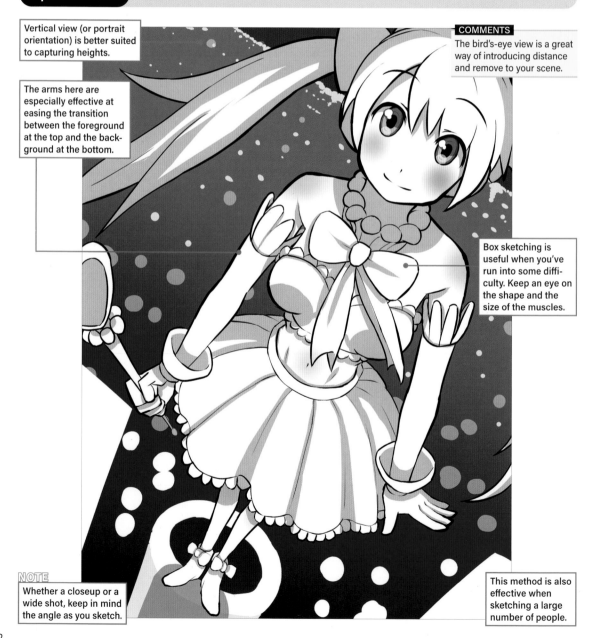

Vertical view (or portrait orientation) is better suited to capturing heights.

The arms here are especially effective at easing the transition between the foreground at the top and the background at the bottom.

COMMENTS
The bird's-eye view is a great way of introducing distance and remove to your scene.

Box sketching is useful when you've run into some difficulty. Keep an eye on the shape and the size of the muscles.

NOTE
Whether a closeup or a wide shot, keep in mind the angle as you sketch.

This method is also effective when sketching a large number of people.

◐ The Basics

As the Crow Flies

With a composition method that shows the subject from above or overhead, getting the perspective right is key, so enlarge the upper portion of the image and reduce the size of the lower part.

More extreme or radical bird's-eye viewpoints give the vantage from high altitudes or from airplanes or birds. For some film directors, it's a go-to perspective for establishing shots or to ratchet up the intensity and drama.

Because the bird's-eye view is a composition method that showcases heights, it's best suited for sketching your images in a vertical layout or portrait orientation.

Because the vanishing point is below, this technique is related to the inverted triangle method (page 30), which is a good choice to highlight moments of tension and instability.

Understanding Solidity and Muscles

The bird's-eye/high-angle view is a composition method that beginners can find challenging at first. Because extreme perspective is so heavily on display here, it's important to bring a strong sense of solidity to your sketch.

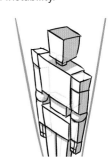

Just like sketching using the tilting method, use box sketching as a practical way of accurately capturing the sizes and shapes of muscles. Drawing muscles is touched on in greater depth on page 166.

Give Good Face

When using the bird's-eye view to feature a character, the most important thing to remember is to augment the face in the front. The bird's-eye or overhead view is also an effective approach when capturing and enhancing a character's cuteness.

● Faces: Bird's-Eye View

Instead of starting with the face as an oval, fitting it at first into a cube gives you an essential sense of balance. By overlapping the head with the cube frame, you can then use it to change and adapt the face into a more ovoid shape.

Although the eyes are in a lower position when viewed from the front, the face is not pointed or stretched downward. In comparison, when viewed from a side angle, the lower part of the face should look slightly more compressed.

● Faces: Tilting

Just like the bird's-eye view, superimpose the cube framework onto the face to maintain balance. Then change it to an oval.

Although the eyes are in the upper position when viewed from the front side, the face isn't supposed to be stretched or pointed upward as well. But the forehead and upper part of the face should look somewhat compressed.

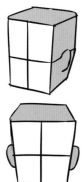
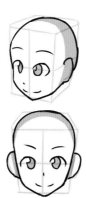
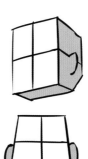

Body Compression

The △ image is sketched using the bird's-eye view method, yet it lacks body compression, so it doesn't fit with the perspective of its background. The exact position of the ground is unclear, so the character looks like as if she's floating in space. Because the bird's-eye view approach can present challenges with the background, place the character and the background on ground level.

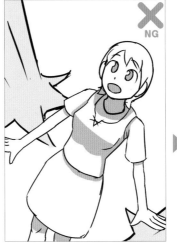

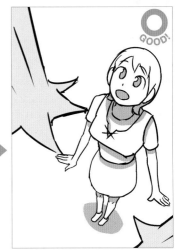

The perspective of the background and the character aren't in balance the character looks as if she's levitating or floating in the space.

Compress the body firmly and then the sense of imbalance and disproportion is gone.

Eye of the Camera

Be careful to identify and maintain the viewer/camera position while sketching from a bird's-eye view. It's important to calculate how much to stretch into the background and foreground when fleshing out the scene. It's a method that's easy to use when sketching the character and the background at the same time. Depending on either sketching the character (1) or the background (2) as the main part, structure the viewer's gaze accordingly.

An example of a closeup view on the character. As the frame is tightly cropped, the character's intensity is increased through the bird's-eye perspective.

An example of a wider, more distant view of the character. The area occupied by the character is minimized, while the background in expanded.

Let's Get Practical

Sketching Large Groups

Compared to tilting and other composition methods, the overhead view is easy to use when it comes to sketching groups or a larger number of people. As you look down from above, the area the bodies occupy decreases, but you can increase the space in which to draw the characters by playing with the viewpoint.

Even if the characters are all smaller in size, with this approach you can make the faces somewhat larger in order to feature and highlight specific characteristics.

Though this topic is of course covered in the entry on group shots (page 114), composition methods that can accommodate large groups are limited. That's what makes the bird's-eye view a valuable tool to master, opening your illustrations to the depth and complexity of three-point perspective. However, adhering to the rules of perspective too closely will cause the illustration to become stiff and lifeless. Therefore, it's better to use box sketching and draw by eye.

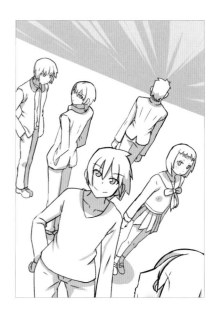

Example

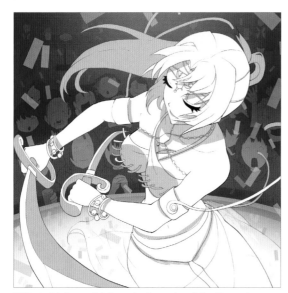

With the bird's-eye/high-angle view, a lot of details can be added and accommodated without difficulty. As with this example, you can draw a large picture by tilting the character's body forward.

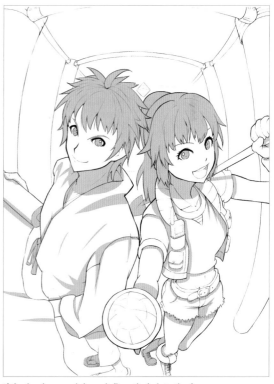

If the background doesn't fit entirely into the frame, you can draw a curved, fish-eyed view of the entire screen.

Compositions That Highlight Characters

Main Characters

This method helps to place your main character center stage. Especially for illustrations featuring a wide view of the background or a lot of details and accessories, it's important not only to place the character in the middle, but also to make sure that he or she stands out.

Tips & Pointers

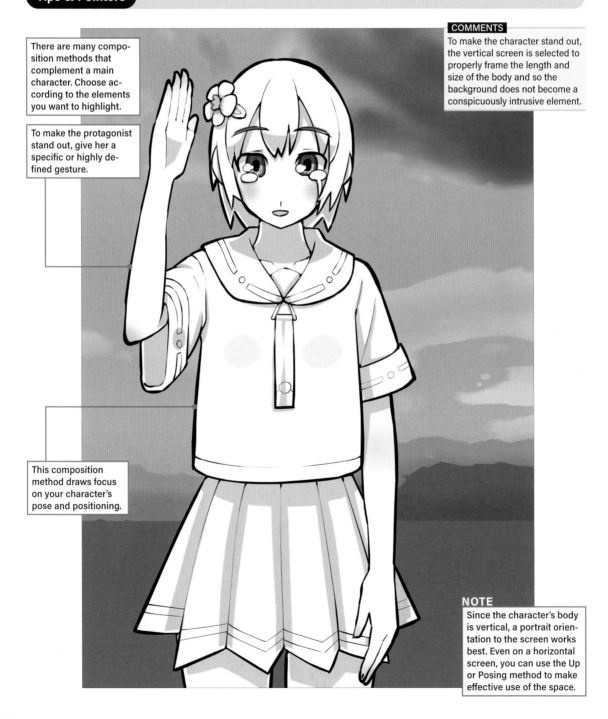

There are many composition methods that complement a main character. Choose according to the elements you want to highlight.

To make the protagonist stand out, give her a specific or highly defined gesture.

This composition method draws focus on your character's pose and positioning.

COMMENTS

To make the character stand out, the vertical screen is selected to properly frame the length and size of the body and so the background does not become a conspicuously intrusive element.

NOTE

Since the character's body is vertical, a portrait orientation to the screen works best. Even on a horizontal screen, you can use the Up or Posing method to make effective use of the space.

The Basics

Spotlight on Main Characters

Your characters are defined by their poses and facial expressions, the distinctive movements, stances and emotional responses that are all their own.

Consider using close-ups (page 86), medium close-ups (page 90), medium shots (page 94), medium long shots (page 98), long/full-body shots (page 102) or combining modes like the two shot (page 106), three shot (page 110) or group shot (page 114) when sketching multiple characters. To make a character stand out, centralize motifs by using the Hinomaru composition (page 34). Or for an artsy touch, use three-part composition (page 50) or an alphabet composition (page 66).

You can also increase detail and clarity with the panel layout composition (page 62) or draw focusing on the image.

Even with a detailed or "busy" background, panel composition keeps the focus squarely on your character.

Let's Get Practical!

Vertically Enhanced

A vertical screen is better for characters that are to be shown in a natural pose or setting. You can draw them on a horizontal screen, but that orientation creates extra margins. The easiest way to draw on the horizontal screen is to divide the field into smaller areas and subsections. This allows the intensity of the scene and the focus on the main character to come through.

You can use the horizontal screen to devise an effective pose for your character. It's a good idea to create a pose that takes into account the triangle composition (page 26), inverted triangle composition (page 30) or alphabet composition (page 66), taking advantage of the wide base and top edges.

An angry expression and pose, but the intensity isn't given its full impact because of the extra margins on the right and left.

Now the face is closer and the expression is clearer.

Posing with a wide range of motion to the left and right. Here the horizontal screen is particularly effective.

Creating a Margin

To make the main character stand out, cut off unnecessary parts and distracting or blurry areas.

As the main-character composition model is figure-based, devised to make your protagonist stand out, it's effective to cut off visual elements and details from the screen that are not part of the main character to simplify the composition.

Another approach is to place characters at important positions based on the three-part composition or Z composition (page 70).

The building in the background is strangely conspicuous.

With just a portion in view, the building has lost its presence.

The building has now been blurred and blended into the background.

Main Objects

Rather than having a person in the spotlight, this method centers on an object or element set against a background or landscape. In anime and manga, often there are scenes in which objects or items of significance, rather than the people, stand out to explain the situation or further the story. Here we'll look at tricks and tips for focusing your viewer's gaze on an eye-grabbing element or object.

Tips & Pointers

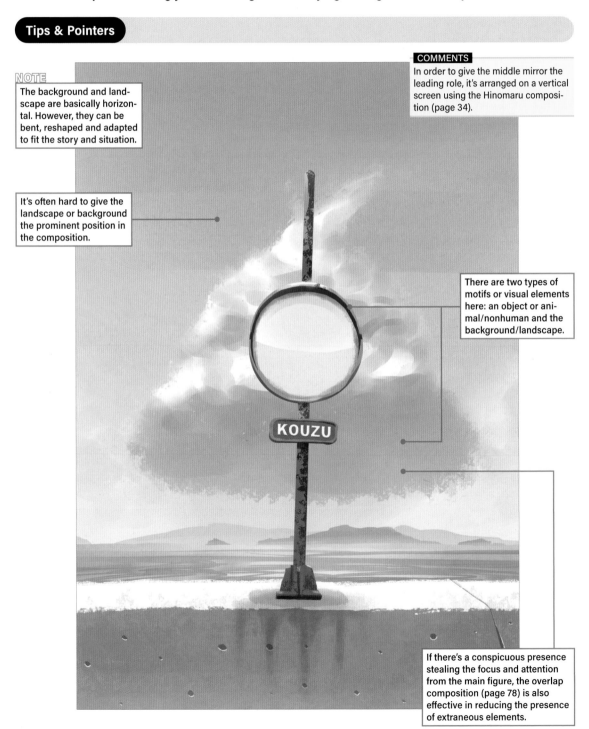

NOTE

The background and landscape are basically horizontal. However, they can be bent, reshaped and adapted to fit the story and situation.

It's often hard to give the landscape or background the prominent position in the composition.

COMMENTS

In order to give the middle mirror the leading role, it's arranged on a vertical screen using the Hinomaru composition (page 34).

There are two types of motifs or visual elements here: an object or animal/nonhuman and the background/landscape.

KOUZU

If there's a conspicuous presence stealing the focus and attention from the main figure, the overlap composition (page 78) is also effective in reducing the presence of extraneous elements.

 The Basics

Let's Be Objective

This composition method targets two main visual components, the objects or nonhuman creature placed within a larger background. In truth, you can treat the item or animal in the same way you would a main character or human figure. It's the background that's trickier, making it prominent and noticeable while not disrupting the overall balance of the scene.

For background and landscape, the two-part composition (page 46) and the three-part composition (page 50) are effective. The diagonal (page 22) and the diagonal line (page 42) composition models are also good for effectively using the background and landscape.

Follow the Horizon Line

When you've upgraded or promoted objects, items or animals to the main role, sketching the portrait using a vertical screen and a landscape on a horizonal view will usually work. Many backgrounds and landscapes employ a horizontal screen. Landscapes typically contain a lot of detail, a wealth of visual information, so a wider horizontal screen is a better choice for expressing the expanse of the world and boundlessness of the atmosphere. However, a vertical screen is the better choice when it comes to accentuating or conveying an object's height, such as a tower that rises high into the sky, or when capturing the airy lightness of clouds or a starry sky.

 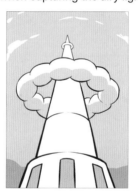

Enlarge or Reduce?

With either the main character or main object composition model, the larger the ratio of the object or element to the screen, the greater its presence will be. For example, if you're drawing a landscape as the main subject, reduce the size and presence of the animals and objects you use to fill in the scene. If instead you want to highlight the presence of a specific element, the overlap composition (page 78) method is effective for viewing elements in perspective. The landscape must be included in the drawing in order to reduce the presence of the other visual elements. You can always increase the size of the animals or other details and place them within a smaller background.

The overlapping composition (page 78) method allows you to stack or overlap different items, objects and elements in perspective, relating them to each other and highlighting or reducing their prominence or presence accordingly. If you have to combine a character with other visual motifs on the screen, remember to reduce the size and presence of the non-essential characters also included.

The subject of the drawing is there, but because it's so small, it blends in with the background.

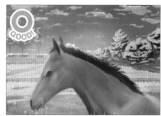

The prominence of the background has been reduced by increasing the size of the horse and by overlapping the background with this main figure.

Look Me in the Eyes

Composing from Eye Level

Eye level is the height of the observer's line of sight. It allows you to unlock the possibilities of perspective. Awareness of eye level can make a huge difference in your scene's compositional elements and the impression it makes. This method unifies the scene into a singular, overall impression—that's your goal!

Tips & Pointers

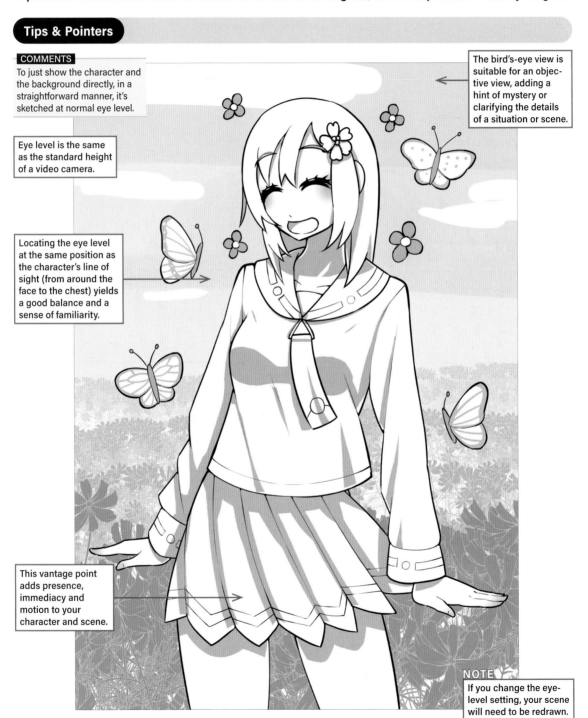

COMMENTS

To just show the character and the background directly, in a straightforward manner, it's sketched at normal eye level.

Eye level is the same as the standard height of a video camera.

Locating the eye level at the same position as the character's line of sight (from around the face to the chest) yields a good balance and a sense of familiarity.

This vantage point adds presence, immediacy and motion to your character and scene.

The bird's-eye view is suitable for an objective view, adding a hint of mystery or clarifying the details of a situation or scene.

NOTE

If you change the eye-level setting, your scene will need to be redrawn.

The Basics

Different Looks for Different Levels

Eye level of course means the height of the eyes of the viewer. However, the eye level is often used to describe the height of the camera as it swoops and soars to heights and angles that humans could not otherwise see.

This section explains how the composition changes with differing eye levels. First, as shown in the figure on the right, suppose that the same image was shot by the camera from above or on high ❶, from the character's line of sight ❷ and finally from below ❸.

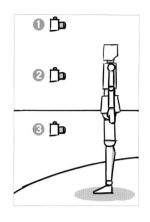

❶ Faces: Bird's-Eye View

The composition takes on a bird's-eye view (page 12). The vanishing point is located in the upper part of the screen, and there's a lot of background included. Because it's easy to include a lot of information without difficulty, it's a good choice for fleshing out the scene or explaining the situation.

Since this vantage point exceeds the limits of human height, and involves sights that could otherwise only be imagined, it infuses your story and scene with mystery and wonder while providing an objective view at the same time.

If you want to show the length and extent of the road with an S-shaped composition, or alphabet composition (page 66), a bird's-eye view taken from too high of an altitude won't work.

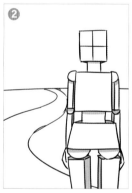

❷ Taken from the same position as the character's eyes

This is where the viewer or the lens of the camera is as tall as or aligned with the character's line of sight. It's easier to understand if you consider the camera position from the character's head to your chest.

This simplified, straight-on, unmitigated approach brings the screen balance and a sense of the familiar to the composition. It's suitable for direct, straightforward expressions or for showing characters in a subdued mode or to control your viewer's emotional reactions. It's also good for rendering the depth of the background with S-shaped compositions.

However, there are limits to this basic approach. If you want your viewers to have a powerful emotional response, this eye-level approach may prove insufficient.

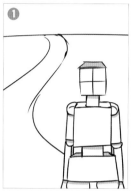

❸ Shooting from a low-angle position

This is the tilting approach discussed on page 8. The vanishing point is at the bottom of the screen and there's a lot of sky contained in the frame. Since the amount of ground or terrain shown has been reduced, this compositional method is especially suited to characters floating in the air or at a high position. This is a good approach for shots highlighting the relation of the viewer to the character being observed, such as a child's viewpoint or a passive or supplicant point of view. Since the shooting position is low, the ground appears to be compressed, so this it isn't a suitable mode for capturing the depth of the road with S-shaped compositions.

In the case of illustrations, as a general rule, once set on eye-level mode, they can't be changed midway. Changing the eye level in the middle of your sketch means you'll have to redo your drawing, so know where you want the eyes to be before you begin.

Intentionally Askew

Diagonal Compositions

To add a sense of instability or a deliberate lack of balance to your illustrations, a slanted line of sight sets your illustrations properly askew. It's a go-to approach that can summoned for a variety of scenes, but it's especially favored for light-novel illustrations and the stills and scene graphics accompanying love-themed games.

Tips & Pointers

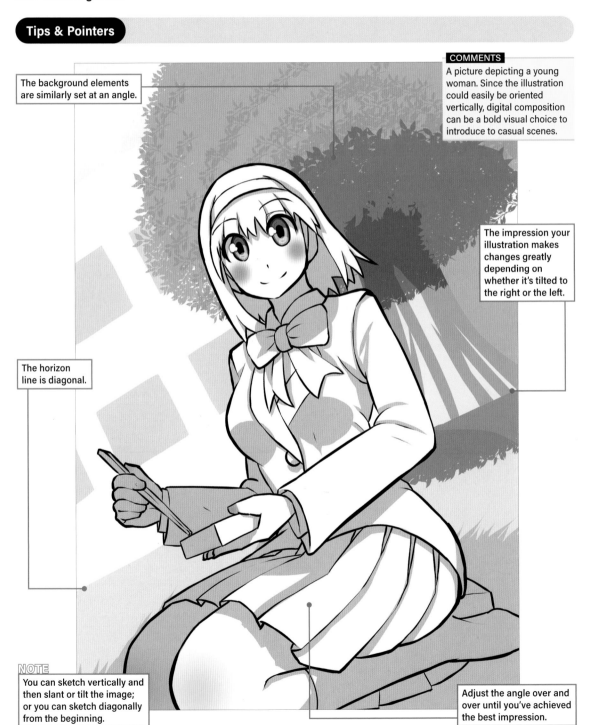

The background elements are similarly set at an angle.

COMMENTS
A picture depicting a young woman. Since the illustration could easily be oriented vertically, digital composition can be a bold visual choice to introduce to casual scenes.

The impression your illustration makes changes greatly depending on whether it's tilted to the right or the left.

The horizon line is diagonal.

NOTE
You can sketch vertically and then slant or tilt the image; or you can sketch diagonally from the beginning.

Adjust the angle over and over until you've achieved the best impression.

The Basics

Slanted Impressions

With the camera's or viewer's line of sight set diagonally, the screen's horizontal line is also slanted. As a result, a sense of direction is created on the screen, and motion can be captured and suggested. At the same time, a sense of instability is created. A scene with an oblique field of view can give a sense of incongruity or a feeling of displacement, deepening the overall impact of the work you're creating.

Doubly Diagonal

There are two ways to draw a diagonal composition: either complete the drawing on the horizontal and tilt it, or set the horizon on the diagonal from the beginning and go from there. The first approach is easy, as it starts with the familiar: the typical straightforward method of producing a standard drawing. However, since the illustration is tilted at the end, the results might be unpredictably disappointing once the effect's been applied. With the second method, there are no last-minute adjustments to upend your expectations (and hard work!). Starting with the perspective already on the diagonal just increases the difficulty of successfully pulling off the illustration.

OR

Choosing a Better Angle

The △ image is an oblique composition, but it doesn't take full advantage of the angularity this method allows. There's no surprise or specific impact the skewed perspective is accomplishing here. If you don't have a set look or approach in mind, find an effective angle by transforming the drawing several times digitally. However, the image will deteriorate if it's contorted too many times. The most effective way to avoid this is to draw in vector format, so that the image doesn't excessively distort. Or you can take a copy of the original image, find the optimal angle and then shift it to match that angle. Doing this just once minimizes degradation and the breakdown of the image.

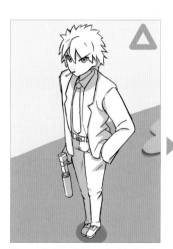

The angle hasn't been decided yet, so the result here is underwhelming.

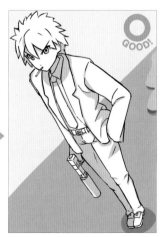

After many adjustments, the optimum angle has been found. The background elements have been slid toward the main character.

23

The Basics

The Impact of the Direction of Tilt

An illustration's impression changes depending on the direction or angle it's tilted, whether it's tweaked to the left or the right. Especially when there are multiple people in the scene, the overall impact alters depending on whether you tilt it to the left or right. The artist's choices are rarely arbitrary when it comes to constructing more complex scenes and illustrations involving skewed perspectives.

The young man's head is positioned higher and the left-leaning perspective gives us his point of view. The threatening impression of the man aggressively closing in on the woman has been intensified.

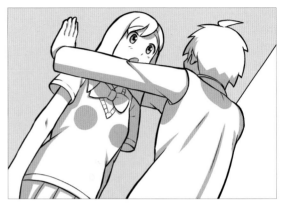

The woman's head is raised and the flow and focus here are to the right, giving a stronger impression here of her emotions and reaction.

EXPERT TIPS ●●●

What Makes a Bad Angle?

A poorly chosen angle can push your illustrations too far to the edge. They'll lack clarity and impact if the distortion becomes the key factor.

Common to the world of photography, diagonal compositions can spark surprise, forcing a new perspective on your viewers, forcing them to reconsider the familiar or the known. A diagonal composition not only conveys a sense of instability and the unfamiliar, it can also suggest dislocation and unease. A sense of incongruity is a difficult element to manage sometimes that can overwhelm or ruin your work. You need to wield the effect in the right way, so it feels right and fits. In the era when only analog, hand-drawn illustrations were possible, many failed drafts, sketches and proofs resulted. But the spread of digital design technology allows for trial and error. You can play with your illustration, shifting it until you find the best solution and perspective. The flexibility and freedom technology offers open a whole new world where sketches and drafts need not be abandoned if they're not initially coming together.

An example of a failed attempt: If there's no reason to make an image diagonal, it only adds distortion or a sense of incongruity.

Perfect for Battle Scenes

The diagonal composition is effective when you're illustrating battle scenes, especially scenarios involving magic and fantasy or firearm sequences. A vertically or normally oriented fight scene means you have to generate the drama and dynamism solely thought the contents and components of the illustration. With an oblique composition, many elements come into play onscreen, such as gaze guidance and the use of concentration lines, intensifying the action you're trying to capture. For additional coverage of skewed approaches, see the section on action poses (page 154), special moves (page 158) and magical activation (page 162). But in the end, a lot of ingenuity is needed in producing powerful battle scenes.

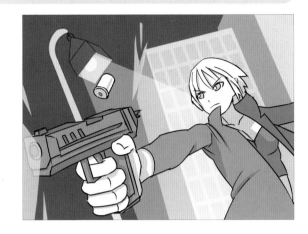

 # Take a Look: Practical Applications

An image of a sidekick who has destroyed everything in a laboratory. The horizon and the sofa in the front are drawn diagonally, increasing the element of disruption and surprise.

Since the dog is the main character, it's tilted so that the line of sight and the movement are directed toward the dog. At the first glance it looks mild, but the slanted effect mirrors the world from the point of view of the student, which creates a sense of incongruity.

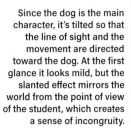

Three-Pointed Rules

Triangle Compositions

Triangular composition is a common way of structuring an illustration, when stability and solidity are the goal. It's a valuable and versatile tool for you to have, useful for producing character designs to illustrations that require you to integrate the background with a number of figures or elements. Leonardo da Vinci's renowned "Mona Lisa" is a triangular composition; it's a format and a compositional approach that's been used for ages.

Tips & Pointers

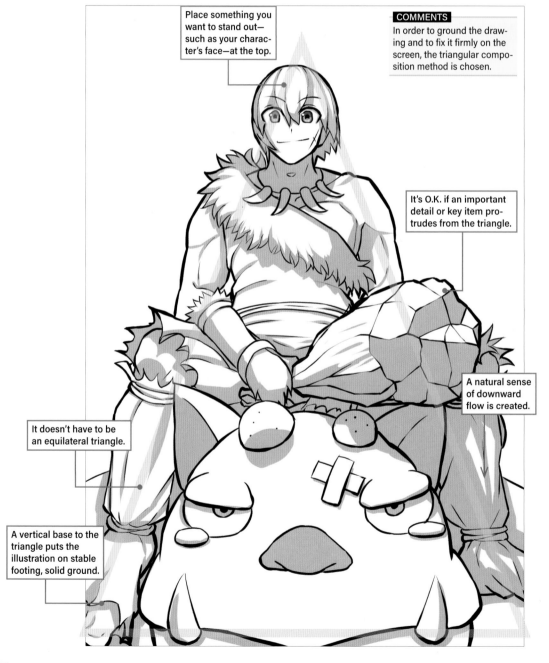

Place something you want to stand out— such as your character's face—at the top.

COMMENTS

In order to ground the drawing and to fix it firmly on the screen, the triangular composition method is chosen.

It's O.K. if an important detail or key item protrudes from the triangle.

A natural sense of downward flow is created.

It doesn't have to be an equilateral triangle.

A vertical base to the triangle puts the illustration on stable footing, solid ground.

 # The Basics

What Is Triangular Composition?

With its center of gravity at the bottom, the triangle is used to express a sense of stability. Using the shape as a general framework, the elements of your scene can nonetheless spread out beyond its borders.

If you try to keep everything neatly inside the triangle, the composition will become stiff.

This is an effective composition choice when you want to draw a powerful character or when you draw a dynamic standalone pose.

The character "breaks the frame," pushing beyond the immediate confines of the triangle.

Standout Elements Go at the Top

When drawing a triangle-based composition, place the object or element you want to stand out most at the vertex.

If it's a character, locate the face at the top. But if there's something else that you want to stand out, bring it to the apex to focus the line of sight ❶.

In group scenes, you can also express power relationships by placing the protagonist or dominant figure at the top ❷.

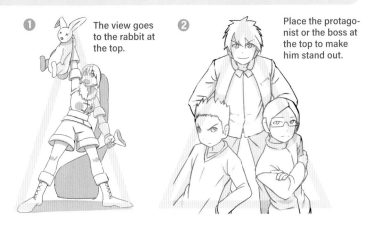

❶ The view goes to the rabbit at the top.

❷ Place the protagonist or the boss at the top to make him stand out.

Group scenes and collective illustrations are difficult to orchestrate and unify, but you can draw and manage them simply through the power of triangulation.

Widen the Bottom

The △ image uses a triangular composition, but the width of the base is narrow and limiting. To improve the drawing, flutter the hair and clothes, spread the legs and widen the bottom of the triangle. The silhouette then becomes more dynamic, and the character's facial expression and pose are more closely aligned.

The overall silhouette is thin, and the facial expression and body position don't mesh with each other.

To increase the size and impact of the figure, fluttering hair and clothes are added: an effective embellishment!

Triangular Thinking

Triangle-based composition doesn't necessarily always lend a strong sense of stability. If the triangle base is shortened and the apex is set high, the composition becomes looser. The triangles used for compositions can be any shape, such as equilateral or isosceles triangles. If the bases are parallel, a more stable impression results, but it's not always necessary to orient them this way.

It can be used for scenes set in precipitous places such as on the edge of the cliff.

An equilateral triangle offers the most stable composition form with its three balanced sides.

Even an equilateral triangle's solidity can be changed slightly by tilting it.

You can change the position of the apex or tilt it.

NG
Be careful not to change it into a different composition if it is tilted too much and reversed.

 # The Basics

A Case of Inversion

The triangle method can be applied to illustrations relatively easily, but it's also a composition method that can lend too much stability, resulting in a bland or uninspired illustration. If that's the case, change the shape of the triangle and shift the composition. By changing the length of the sides to make them unequal or by stretching the triangle diagonally, you can express the movement.

This is a very sharp triangular composition that's diagonally conscious. By placing the foot at the apex, it expresses the power of the kick.

In this example, the rhythm is generated by using an irregular triangle. The triangle composition may give an impression of being overly stable, so it's a good idea to add depth and variation using tilting (page 8) or the overlap composition (page 78) method.

Take a Look: Practical Applications

A triangle composition featuring two characters. In a scene involving the need to absorb and withstand explosions, the containment and stability of a triangular composition works well.

© Adrenalize Co. Ltd "Investigator One-One"/Sejiya Fujiwara

This approach is also a good choice for featuring the strength and grace of a striding hero.

© Studio Automaton/Yasunari Kobayashi

EXPERT TIPS ● ● ●

Is There Such a Thing as Square Composition?

So at this point you may be wondering, if there's triangle-based composition, is there a square-centered composition model as well? Of course there is!

It's not surprising that the square-based approach contributes even more stability to an illustration than the triangle method.

The square-shaped field allows you to fill the frame any number of ways. Alphabetic forms are a helpful way of conceiving of the space, such as the exuberant X shown here. I-type and V-type composition are two alphabetic methods that allow you to maximize and control the space your figure fills.

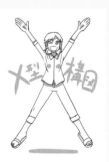

Inverted Triangle Compositions

Like with triangle composition, this related approach introduces not only motion and movement to your illustration but heavy doses of tension as well. It's a mode used even when drawing just characters, but it can lead to unusual or unexpected results, so it should be used and applied carefully. In paintings depicting Christ's crucifixion, for example, an inverted triangle composition was often used to capture the intensity, agony and hushed reverence of the scene. Like the triangular composition, it's an artist's tool that's been around for ages.

Tips & Pointers

As long as it doesn't overstretch the composition or break the frame, it's O.K. if elements protrude somewhat from the inverted triangle.

COMMENTS
An inverted triangle composition, with its compressed tensions, is the perfect choice for a scene of horror, threat or menacing dread.

When the upper side is parallel to the top of the screen, a certain degree of stability is achieved.

The center of gravity is located on the screen.

It's O.K. if the lengths of the three sides aren't equal or don't align.

The screen becomes less balanced when the acute angle is lowered.

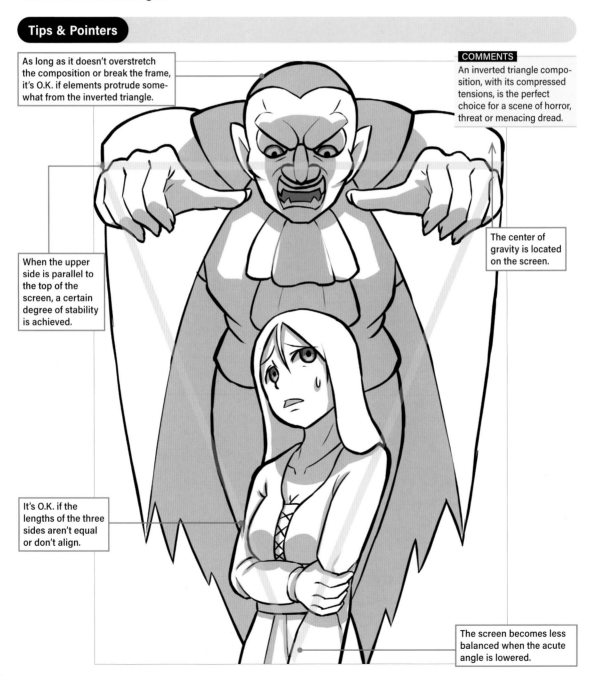

▽ The Basics

Pointing Up and Pointing Down

With inverted triangles, the center of gravity is located at the top. Like a spinning top, the heavier elements are in the upper portion and the lighter elements at the bottom.

Despite the instability the structure introduces, it also unifies your illustration, grouping and interrelating the elements. This is an effective composition when you want to create a sense of tension or imbalance. For example, it's an effective match for a character walking a tightrope, along a precarious height or a drawing in which a character is falling.

Set in Motion

Like triangle composition, inverted triangular composition is a mode that is easy to manipulate. This is because, in the case of a triangle, an acute angle is always created to serve as a unifying or focal point, and the tip of the triangle acts as an "arrow," directing your viewers' attention. Its downward-pointing triangle draws the line of sight to the bottom of the composition, already invoking a sense of falling or downward motion.

More Effective Inverted Triangles

The △ figure makes use of the inverted triangle method, but a stabilizing rectangular element has been introduced by opening the legs, forgoing the instability that is the hallmark of the inverted triangle composition. So the first example needs more impact.

In this case, you can emphasize the inverted triangle by narrowing the distance between both feet or by widening the upper leg of the triangle.

The inverted triangle composition also increases the impression of weight or heft your characters have, the persuasive power of carrying heavy objects and wielding great force. As a result, the character's impact is intensified.

Since the legs are slightly separated, the silhouette's a square. To give a sense of instability, the balancing effects of the square aren't the best choice.

The upper portion's center of gravity has been increased, and the lower body tapered into the acute angle.

◯ Let's Get Practical

Tilting the Inverted Triangle

With this composition model, try changing the length of the three sides to make them unequal or make the inverted triangle diagonal. The acute angle is typically located at the bottom of the screen. If you want to play with your illustration, be sure to tilt and relocate it as well.

A salute to all her fans: By setting the acute angle on a slant, it was possible to enhance the sense of movement in the drawing.

With some composition models, the figure is drawn on a flat plane to accommodate the shape. In this way, creating a composition with depth in mind is also an effective way to produce a polished, sophisticated, professional work. To elevate or advance your illustrations, have a sense of the depth you want to create before you begin, so your character leaps off the page in a more dynamically complicated pose.

EXPERT TIPS ●●●

A Wedge of Muscle

Some people have a hard time when it comes to drawing muscular male or masculine characters. If this is you, the inverted triangle might be the simple solution. The bodybuilder's frame is a good way of thinking about the shape, bulky and wide at top while tapering to a compact point at the bottom.

Even if your characters are not muscular—or masculine—harness the power of the triangle for a sense of tension and motion as well as for a sense of polish and a better overall finish.

In the Margins

When working with an inverted triangle format, don't forget about the role and power of margins and spaces. In the figure on the right, an inverted triangle is placed at the top of the buildings to suggest an open, gaping view of the sky. In addition, by placing the leading character at an acute angle, the line of sight can be concentrated naturally.

As with margin compositions (page 54), you need to introduce specific objects, such as characters and buildings. The margin is an important component, so consider carefully how its use comes into play. For a better result, take advantage of spacing and perspective to harmoniously fit various elements into the picture and achieve the proper balance.

▽ Take a Look: Practical Applications

This was the cover of the light novel "Kokohore ONE-ONE!" An inverted triangle is formed by arranging the two people. Since the top of the inverted triangle offers a wide-angle aerial view, it's also suitable for drawing from a bird's-eye angle (page 12).

© Kabushikigaisha adorenaraizu "Koko hore wan-wan! (1)" Ogawa Issui

This is an illustration for the online game "Silver Rain." An inverted triangle composition is used here to emphasize momentum. By placing a heavy object (like a wooden mallet) underneath, stability is achieved even in this notoriously unstable format.

© Kabushikigaisha tomīu-ōkā "Shirubārein"

Highlighting a Main Character
Hinomaru Compositions

Meaning "circle of the sun," Hinomaru refers to the emblematic red-dot sun centered on the white field on the Japanese flag. In art and photography, the compositional approach borrows the same concept: the main subject is prominently and centrally featured in the middle of the illustration.

It's an effective approach for an uncluttered and grounded way of highlighting your illustration's main subject. It's also a simple approach that can be utilized by artists of all levels, beginner or advanced.

Tips & Pointers

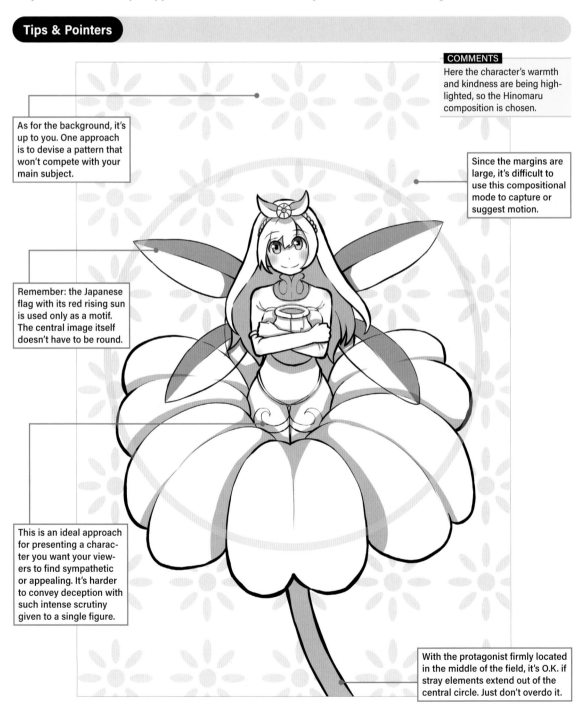

COMMENTS
Here the character's warmth and kindness are being highlighted, so the Hinomaru composition is chosen.

As for the background, it's up to you. One approach is to devise a pattern that won't compete with your main subject.

Since the margins are large, it's difficult to use this compositional mode to capture or suggest motion.

Remember: the Japanese flag with its red rising sun is used only as a motif. The central image itself doesn't have to be round.

This is an ideal approach for presenting a character you want your viewers to find sympathetic or appealing. It's harder to convey deception with such intense scrutiny given to a single figure.

With the protagonist firmly located in the middle of the field, it's O.K. if stray elements extend out of the central circle. Just don't overdo it.

◉ The Basics

A Spotlight Effect

With the Hinomaru approach, all eyes are drawn to this key, central uni-fying point, as if a spotlight is fixed on your character, establishing all the more his or her leading role. Centralizing the image also acts as a stabiliz-ing force for the overall composition.

Just keep in mind that the figure or object you're assigning the starring role to need not be circular, just centrally located.

It's also a go-to approach for people who don't feel confident drawing in the background, so foregrounding the main subject reduces the amount of surrounding detail that will be seen.

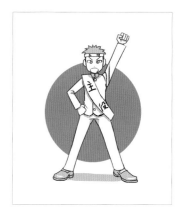

Center of Attention

The object or figure being highlighted need not be isolated within the center of the illustration. Here the tower extends below and beyond the bottom of the illustration. That doesn't detract from the fact that the bell is the main item of focus.

In addition, unlike the traditional Hinomaru design--a single dot placed on a solid background with no other visual elements in the field--the main character motif does not necessarily have to be arranged or isolated inde-pendently.

As a result, the Hinomaru composition only has to follow the simple and basic principle that the main object of focus is placed at or near the center.

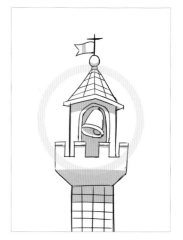

A Lens-like Focus

The △ figure in the image is a simple character centrally lo-cated; but the illustration feels safe and lacks impact. In this case, it's better to increase the area that the character occu-pies on the screen. Since the Hinomaru composition is a standard, familiar and widely used approach, try to place an eye-grabbing or larger-than-life character in the spotlight so the effect isn't diminished.

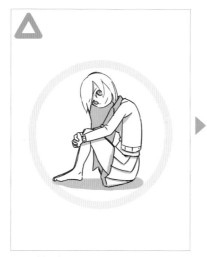

Everything here is too straightforward, too simply rendered. Since there are wide margins, a sense of dislocation or loneli-ness is created.

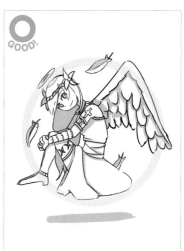

Rethinking the character design itself, the figure is changed into an angel. The area that the character occupies is increased and the impact is intensified.

Inconspicuous Backgrounds

With the focus on the figure in the middle, the star, it's easy to overlook the presence of the background with this approach. No matter what, avoid a conspicuous background or one that competes with the presence of your main character (unless you have a specific intention).

That doesn't mean you can't draw a detailed or richly complicated background. For example, in an illustration featuring a rocky landscape, the central image can stand out all the more through the use of contrasting elements and colors that float on the screen.

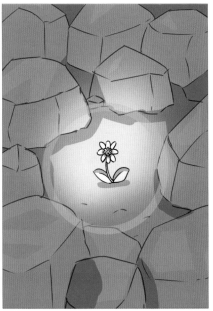

By blurring the background, the main figure has been brought into focus, if not stark contrast.

The flower's conspicuous because of the contrast not only in brightness but also between the main elements: the bloom and the rocks. It's a frame composition (page 58) at the same time as an example of a Hinomaru composition.

EXPERT TIPS ●●●

Simple Is Best

This approach is certainly favored by beginning artists and those unsure of their ability to produce a realistic or detailed background or landscape. However, on the flip side, it's the simplicity and purity of the approach that allows for masterful, accomplished work to be produced. An accomplished Hinomaru composition is often a work that arrives at that composition as a result of paring down the extraneous and leaving only the necessary items.

By privileging clarity and simplicity, this approach is able to convey large amounts of visual information to your viewers. In the world of photography, some say that the proof of a first-class photographer is the ability to take amazing photos based on the simplicity of Hinomaru composition: the main subject front and center. It might also be the case with illustrations!

⦿ Let's Get Practical

In Case of Co-Stars

The Hinomaru composition can be applied even when there are multiple characters or elements in the same illustration.

If the figures are arranged separately or independently on the screen, the drawing won't make effective use of the Hinomaru approach. To effectively use the Hinomaru composition with multiple subjects, combine the various visual elements into one. Combine the motifs once in another composition, then place the result into a new illustration as a Hinomaru composition.

In the figure on the right, multiple motifs are combined into an inverted triangle composition, and then the Hinomaru composition is created. Keep in mind: Instead of applying only one composition method to your illustration, combine multiple approaches according to the amount of time you have and the needs and flexibility of the drawing.

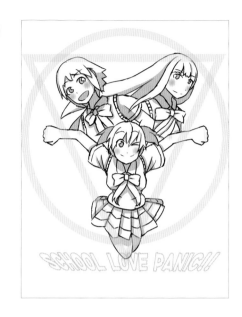

⦿ Take a Look: Practical Applications

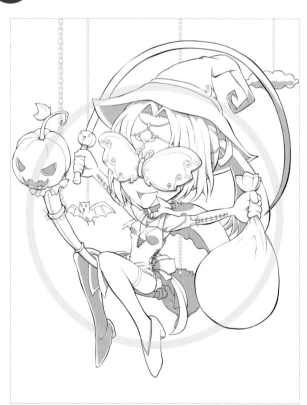

This is a caricaturized or chibi-style Halloween-themed illustration, created for the online game *Mugen* No *Fantasia*. The Hinomaru composition, like the circle composition, is ideal for kawaii-inspired cuties or other lighthearted renderings.

© Kabushikigaisha tomīu-ōkā "Mugen'nofantajia"

This work was made for a company in Miyajima. Character packages need to attract customers first, so the Hinomaru composition is the best choice. The rounded impression here is enhanced using the bird's-eye view (page 12).

© Kashidokoroki mura "Kaki uchi musume"

Circle Compositions

This approach expresses stability and harmony and has a variety of applications. It allows various characters (and their story lines) to be referenced in one balanced composition, unifying and tying the group together in a tableau.

While the Hinomaru composition (page 34) highlights one of the main roles, the point of the circular composition has the effect of enhancing and utilizing the entire screen. Because it lends an illustration a strong sense of balance, it's most effective for group pictures such as the group shot composition (page 114) where many people and personalities come into play.

Tips & Pointers

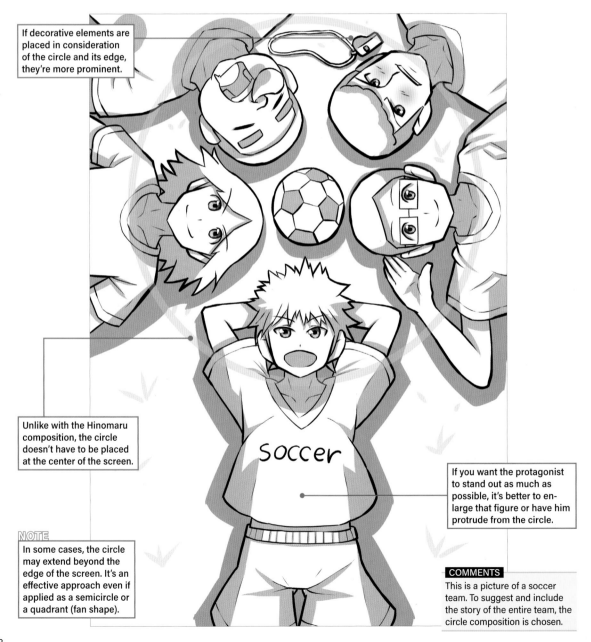

If decorative elements are placed in consideration of the circle and its edge, they're more prominent.

Unlike with the Hinomaru composition, the circle doesn't have to be placed at the center of the screen.

If you want the protagonist to stand out as much as possible, it's better to enlarge that figure or have him protrude from the circle.

NOTE
In some cases, the circle may extend beyond the edge of the screen. It's an effective approach even if applied as a semicircle or a quadrant (fan shape).

COMMENTS
This is a picture of a soccer team. To suggest and include the story of the entire team, the circle composition is chosen.

◎ The Basics

Running in Circles

Because it's circle-based, there's no specific angularity to consider with this approach and every vantage point or line of sight is treated equally, so multiple personas can be introduced. The method is also especially useful when you want to see the entire illustration rather than isolating or highlighting a specific aspect or element.

Often used in conjunction with the Hinomaru composition, the circle-based approach has the added advantage of highlighting multiple characters rather than singling out one individual for attention. You can use Hinomaru composition to place the protagonist in the center so that he or she still stands out from the crowd.

Arrangements and Shapes

Circle composition is more flexible than Hinomaru composition. Of course, placing a circle at the center on the screen will create a stable feeling and a more unified visual field, but unlike Hinomaru, you don't have to place the circle exactly at the screen's center. It's a difficult composition to change, so depending on the time you have and the demands of the illustration, you can try placing the circle vertically or horizontally.

The shape need not be a perfect circle, it can be somewhat distorted, or it may be partial or broken up, as long as it still suggests or gives the impression of the circle. Just don't be too free and distort the shape too much. You don't want your circle morphing into a triangle or a square!

Making Changes

The △ characters ranging around the circle are the same size, but the overall illustration has less sharpness and definition. In this case, in order to make the protagonist stand out, there are other methods than the Hinomaru composition to lean on. Change the location of the main character or enlarge him. Alternately you could change the position of your main character by changing the position of the circle, or by removing him from the circle altogether.

The character in the front with the armband: Is he the protagonist, the distinctive one meant to stand out? With the flat treatment of the characters, it isn't exactly clear.

The situation is clarified by changing the size and placement of the protagonist and breaking up the flow of the circle. The illustration gained sharpness and focus as a result.

◎ Let's Get Practical

Semicircles and Quadrants

While this composition model isn't the best choice for suggesting movement or transformation, it's nonetheless a flexible mode, as the circle doesn't necessarily have to fit entirely within the screen. If you enlarge the circle and cut it off at the edge of the screen, the quadrant creates an enhanced sense of space and movement and a new direction for you to work with.

A semicircle made from the character's own fluttering hair. Circles can also be formed using clothes such as cloaks, another effective way of introducing movement and direction to your work.

The scene of the mermaid princess helping the prince is based on the quadrant concept. While creating an open space for her underwater realm in the lower left, the upper part becomes tauter, more compelling and better organized.

EXPERT TIPS ● ● ●

Seeing Spots

In the circle composition, one basic circle is primarily used, but it's not uncommon for there to be multiple circles present onscreen, as shown in the example. Just use caution, as it's possible to introduce too many circles to a single illustration.

The circle is a centralizing and stabilizing design element. Even if there's only one on the screen, the line of sight is immediately drawn to it. However, multiple circles on the screen will compete and potentially cancel one another out. It'll be difficult to know which one to look at. Circles are potentially appealing and eye-catching because they mirror the shape of our own eyes. If you use multiple circles, devise ways to introduce variety and contrast, such as using different-sized shapes or introducing a blurring effect to some of the elements.

The Softer Side

The circle composition is a great approach for a scene requiring a gentler touch or conveying acts of kindness. Another advantage of the circle's sinuous qualities is to have your character's figure match and mirror its curves. In this case, the S-shaped pose (page 124), which is also a curve, is a highly compatible approach. The figure on the right is a version of the title character from *"Alice's Adventures in Wonderland."* The title character is drawn in a circle-conscious pose while at the same time assuming and forming an S-shaped pose. The screen is tightened and unified by surrounding it with elements related to Alice. The triangle composition (page 26), the inverted triangle composition (page 30), the Hinomaru composition and the circle composition models that we've looked at so far are great to use for simple basic figures. These shapes are easy to employ, and you can complete your work with a single composition choice. Just remember that any composition model can be applied.

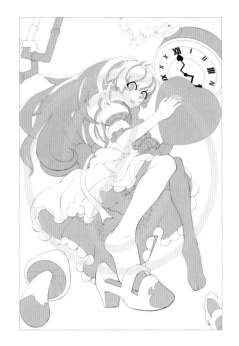

⊚ Take a Look: Practical Applications

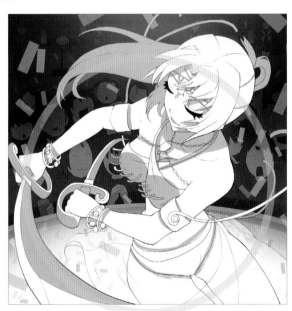

A circle incised by a curved sword blade and the heroine's flowing hair. The other parts are drawn with the notion of curves and circularity in mind.

© Tommy Walker, Inc. "Infinite Fantasia"

The cloak becomes part of the circle. It's not an essential addition, but it's intended to fill in the margins, bring out a sense of excitement and guide and return the viewer's line of sight back to the character.

© Torigami Miyamax

Slanted and Skewed
Diagonal Line Compositions

Diagonal line composition is ideal for suggesting motion and movement and for capturing depth. It's a great approach to master and to have in your tool kit, as artists at all stages, from beginner to advanced, rely on the slanted perspective and off-balance tensions the diagonal axis allows. Since it's compatible with various other composition modes, it has a wide range of applications and will help lift your illustrations to the next level.

Tips & Pointers

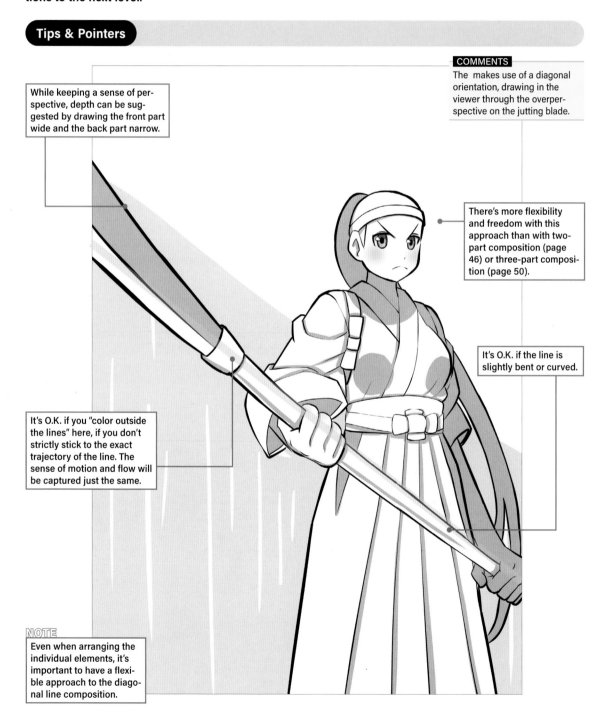

COMMENTS
The makes use of a diagonal orientation, drawing in the viewer through the overperspective on the jutting blade.

While keeping a sense of perspective, depth can be suggested by drawing the front part wide and the back part narrow.

There's more flexibility and freedom with this approach than with two-part composition (page 46) or three-part composition (page 50).

It's O.K. if the line is slightly bent or curved.

It's O.K. if you "color outside the lines" here, if you don't strictly stick to the exact trajectory of the line. The sense of motion and flow will be captured just the same.

NOTE
Even when arranging the individual elements, it's important to have a flexible approach to the diagonal line composition.

⊘ The Basics

Slanted and Skewed

Unlike two-part or three-part composition, there's no need to stick to strict definitions of horizontal and vertical, so there's a great degree of flexibility and freedom to this approach. That's understandable as the diagonal lines are summoned to create movement and rhythm. Depth can also be expressed when combined with perspective. The diagonal line can be interrupted on the screen. It doesn't have to cross it entirely.

Those who are used to the Hinomaru composition or who are new to digital illustration can look to this model as a way to break down and subdivide the screen, offering partial or segmented views of items and objects you introduce to your drawing.

Doubly Diagonal

There's no rule saying you have to adhere to one diagonal line per screen. When drawing roads, multiple lines such as guardrails are generated in addition to the lines running parallel to the road itself.

You can also crisscross lines so they form an X. This is a technique often used in establishing a specific perspective, directing the viewer's gaze to a particular point of focus in the illustration. It's at this key intersection where you can place you main character, accentuating all the more his or her starring role.

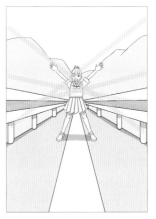

Don't Get Boxed In

The △ figure is a diagonal line composition that crosses the screen entirely. The signpost is placed behind the protagonist to complete the diagonal. This is an awkward and ineffective choice, aligning the figure and the object, as it looks like the post is growing out of the character's head.

Even if the diagonal line does not cross the full screen, it's suggested and established by only its partial length. Here, even a solitary character is sufficient to successfully produce a diagonal line composition.

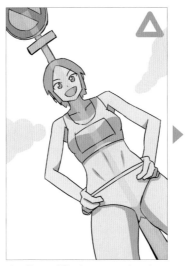

The diagonal line is too prominently established here, resulting in the odd alignment and the mistaken impression that the woman and the signpost are somehow fused, a single entity.

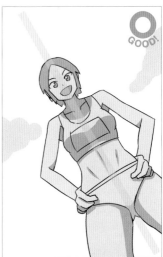

Even a composition with a partially slanted figure establishes a diagonal line composition if the character is tall enough and fills most of the frame.

Let's Get Practical

The lines in the diagonal line composition don't even need to be lines per se. Two or more objects or figures placed side by side are enough to establish the necessary trajectory and sense of flow on the screen.

In Figure ❶, foods arranged in front and diagonally behind are used, creating a sense of motion and flow onscreen and forming a diagonal composition through the use of the multiple dishes. Depth is created when the arranged elements overlap each other, but even if the elements are scattered across the screen, as in Figure ❷, a diagonal line composition still results.

If you find that a sense of flow is difficult to capture when you draw, try moving the elements back and forth and left and right, taking full advantage of the fluidity of the digital space.

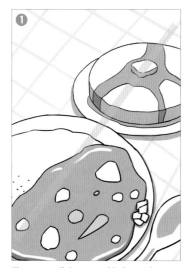

These two dishes stand in for and serve as the strictly inscribed guide lines crossing the screen and establishing a sense of the diagonal through the spatial relationship between both.

Here the spaced-out lanterns mark period points along the diagonal. The person placed at the end is part of the line, completing it. In a looser less literal and less direct way, the careful placement of the elements in the illustration guides the viewer along the line of sight to the person waiting there at the end.

EXPERT TIPS ●●●

Get in Line

Be careful when working with the lines used in the design, especially the ruled lines that delimit and define the design area. This is because the lines that are supposed to be used as design tools are often more eye-catching than other design elements. In this case, make the line thin and use a light color, or choose a broken line instead to break up the balance and flow.

The same is true for the elements making up a diagonal line composition. It's fine if you want to make the line itself the main focus, but if you want to use a diagonal line as the essence of the illustration, be careful not to draw too much attention to it or give it too prominent of a focus. This attention to balance is important for other compositions as well. If the composition is too strong and you get an unintended result, try removing or breaking up elements to soften and mitigate the overall effects.

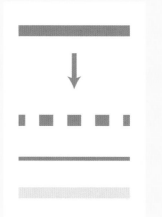

Plays Well with Others

Try combining the diagonal line approach with other composition models.

Since this approach comes with a high degree of freedom and flexibility, it combines easily with other modes. You can incorporate it into another compositional model from the beginning or feel free to add it as an enhancement, if you feel that there isn't enough depth or movement onscreen.

Naturally this skewed way of approaching your illustration pairs well with diagonal composition (page 22). If you use it with a compositional model lacking in intensity, motion and dynamism, such as a Hinomaru composition (page 34) or a circle composition (page 38), the screen will come to life and the illustration will attain a new level of refinement.

When combining diagonal directionals with a two-part or three-part composition, either the vertical or horizontal line plays the leading role, so be aware of how prominently that axis is being featured. If you don't want the diagonal line to stand out too much, divide it across the screen, separating it into partial segments that will still combine to create a sense of dimensionality and movement.

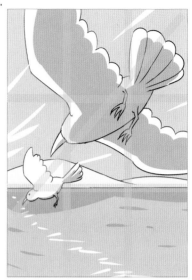

 # Take a Look: Practical Applications

It's not a dynamic movement, but motion and intensity are suggested by the intersection of numerous lines. In addition, the line of sight is well-established and easy to locate due to the concentrated effect of the drawing's various lines.

© Student: RE

Two-Part or Split Compositions

Two-part composition divides the screen, either top and bottom or left and right. It's especially effective in stabilizing your illustration, infusing it with a sense of balance and order. It's also not surprisingly a great approach for establishing sharp contrast or stark differences between the two visual fields.

Since the screen is divided at the center, you can place your main character on one side and a key object or element on the other side, using the illustration to suggest or clarify the relationship between the two.

Symmetry composition, similar to the two-part approach, will also be covered here as another great way of bringing harmony and unity to your drawings.

Tips & Pointers

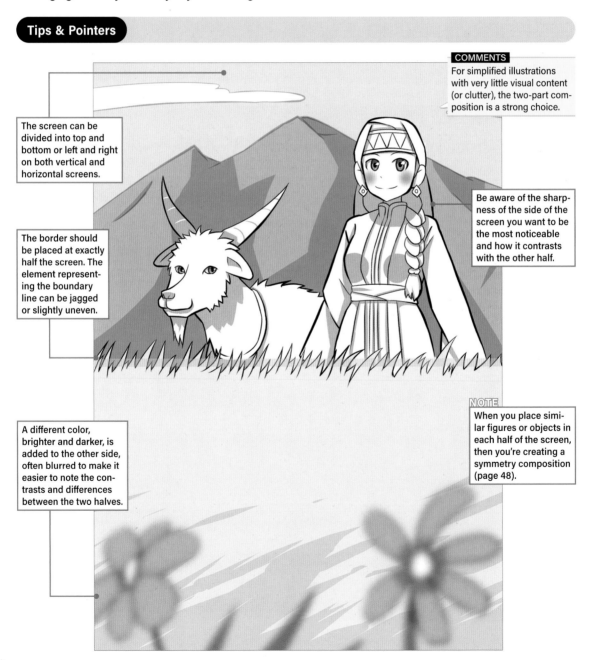

COMMENTS
For simplified illustrations with very little visual content (or clutter), the two-part composition is a strong choice.

The screen can be divided into top and bottom or left and right on both vertical and horizontal screens.

The border should be placed at exactly half the screen. The element representing the boundary line can be jagged or slightly uneven.

Be aware of the sharpness of the side of the screen you want to be the most noticeable and how it contrasts with the other half.

A different color, brighter and darker, is added to the other side, often blurred to make it easier to note the contrasts and differences between the two halves.

NOTE
When you place similar figures or objects in each half of the screen, then you're creating a symmetry composition (page 48).

⊕ The Basics

Two Degrees of Clarity

Since the screen is organized and divided neatly down the middle, this composition model brings clarity to your image, so it's good for illustrations used to explain a situation or offer a definitive resolution.

This mode is also especially suitable for landscapes. As an easy-to-understand example, you can use the horizon to divide the sea and sky or the field of flowers and the mountain landscape into equal parts.

Dividing Lines

Boundary lines divide faces horizontally or vertically. Boundaries should be basically either horizontal or vertical.

In the two-part composition, the boundary line, either vertical or horizontal, bisects the screen. If the boundary line is slanted, then a feeling of dislocation or unfamiliarity is created. Horizontally diagonal lines have another effect: Look at the sections on diagonal composition (page 22) and diagonal line composition (page 42) to bring this dimension to your drawings.

The elements that mark the dividing line on your screen need not be strictly linear. They can be slightly bumpy, blurry or rough-edged. As long as it has the effect of dividing the screen into equal parts, the border can be anything you want!

Clarify and Contrast

Figure △ is composed using the two-part approach, but the main character isn't clearly represented, making it a murky and mediocre rendering that hasn't accomplished its expressed intention. For a better result, place your protagonist on one side as shown in figure ○.

Although the image is perfectly divided in two, the result seems too staid and too balanced, so a little more sharpness is needed.

The appearance of your main man on one side creates a clear contrast on the screen, and thus a much more successful illustration.

⊕ Let's Get Practical

Splitting the Screen

Up to this point, we've mainly looked at how to divide a screen using simple horizontal lines, but let's find a more interesting way to split it. How about a tree or a telephone pole jutting up through the center? Half-open doors, fences and windows are also good for breaking up the screen.

A divided screen that creates its contrasts through the interplay of light and shadow. The element that serves as the dividing line need not be a tangible, physical object within the scene. Here a compelling scene is created simply by contrasting light and dark tones.

The girl is peering through the open window. By depicting the background in front of the window on one side, the outside world that the girl admires is also imaginatively and boldly brought into the illustration.

Feeling Symmetrical

Symmetry composition is a related approach that places a similar image on each of the two halves of the screen. The actual figure or object you choose to feature need not be exactly symmetrical. With the two-part approach, placing a matching or identical figure on both parts isn't recommended; the two sides of the drawing will compete and cancel each other out. With a symmetrical composition, the same image appearing in each half has a more stabilizing effect on the screen. This is useful for drawing twins or good-evil pairings, just be sure your two halves don't become monotonous or too similar that the distinctions aren't readily apparent.

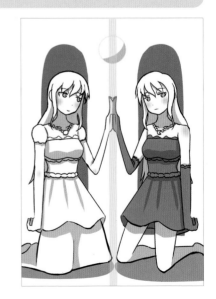

 # Take a Look: Practical Applications

Symmetry composition is established even if the pose or silhouette is not identically or similarly shaped. But the two figures do need to be roughly comparable in appearance or the illustration will confuse rather than intrigue your viewer.

EXPERT TIPS

Backgrounds and the Line of Sight

For the backgrounds of some games, the pictures are often taken while location scouting. When shooting these scenes, it's essential to hold the camera so that eye level (page 20) is at the center of the screen.

Watch the background carefully in the games you play and the anime you watch. There should be numerous examples where eye level is located in the center of the image.

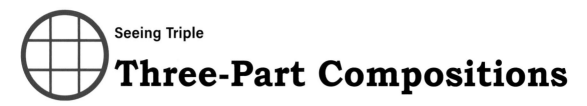

Seeing Triple

Three-Part Compositions

As its name suggests, this approach divides the screen into three parts, either top to bottom or left to right. It is also a guide when determining spatial relationships in your illustrations.

By being conscious of the lines dividing the screen in three and their intersections, you can impart a unified impression to a scene that at first seems chaotic or scattered.

Tips & Pointers

Regardless of whether the screen is oriented vertically or horizontally, it's equally divided into three parts.

COMMENTS

In a busy or densely populated scene, the three-part composition is applied in order to make each element stand out as much as possible.

Elements that you want to be especially noticeable are placed at the intersections.

Not as strict as a two-part composition, the freedom of the three-tiered approach allows you to locate individual elements slightly off the line or away from the various intersections.

NOTE

Play with the placement and location of the illustration's main parts, aiming for a "surface tension" where the three elements play off one another.

The element does not need to straddle the entire line, as long as it covers a portion of it.

⊞ The Basics

Triple Threat

With this approach, nine fields are created once the screen has been subdivided. Whether it's a relatively simple, straightforward composition, like the one to the right, or a more layered and detailed scene, like the one on the previous page, this is an effective way of controlling the creative space. Also called grid layout in the design world, this is a common technique that allows artists of all stages to impose order and balance on their illustrations.

There are three main ways to use the grid:
- Placing an element on one of its lines
- Placing elements at its four intersections
- Placing elements on the faces separated by a grid

It's most effective to place important elements on the line, especially at the intersection.

Keep a Third in Reserve

The three-part screen allows you to combine various visual themes into the same illustration. For example, use one-third of the screen for a related image or margin element, then devote the remaining two-thirds of the space for the main subject. A new sense of balance is created, while subtly setting off your protagonist or the key image you want to highlight in the main portion of the drawing. As this approach tends to be more flexible than two-part composition, the relationship of the space to the visual elements can be adjusted and shifted. Play with it until you get it right.

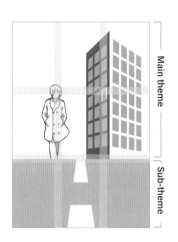

Main theme

Sub-theme

Spatial Relations

This work △ is based on the theme of astronomical observation. The building takes up two-thirds of the screen, too much space for something playing a minor role in the illustration. The overall impression is weakened as attention is detracted from the rooftop observer in an illustration based on the starry sky. On the other hand, in figure ○, the ratios are reversed, the building takes up a third of the space and the starry sky takes up the rest. In addition, because the person is placed on the line, the result is a clearer picture.

Remember to adjust the space based on the content or theme you want to express.

Too little space has been devoted to the scene's key element or action. It looks as if the building is the star of the show here, not the astral activities occurring up top.

By giving the largest space to the central character, it's immediately apparent for viewers what's going on here. The protagonist rearranged on the grid lines creates an illustration that makes better use of space.

⊕ Let's Get Practical

Crisscrosses and Intersections

As we'll also look at with Z compositions (page 70) and margin compositions (page 54), the impression of a visual detail changes depending on where it's placed. Even if you think the illustration is complete, it's important to take the time to change the position of the characters and other elements to see if a better arrangement and a stronger drawing results.

Three-part composition allows for balanced margins. The balance won't be lost even if you change the layout. Although it's a technique unique to digital illustrations, let's experiment here with various arrangements.

① This is an example where the protagonist is placed in the upper left, an unexpected place to locate the main character and action.

② Here the protagonist is placed in the upper right. Although it makes more successful use of the space than ①, it's still not the ideal place for your main character to be.

③ The main character is now in the lower left. Again, it's not where you want him to be, but because the heaviness of the water tower is solidly beneath him, this version has better balance and stability.

④ Now for the lower right. The heaviest elements are again placed underneath, and this position, the last of the four line-of-sight intersection points in the grid, proves the strongest choice.

EXPERT TIPS ●●●

Subdivisions

In breaking up your visual field, why stop at three? Four-part and five-part compositions allow you even more possibilities for arranging and ordering your illustration. Nevertheless, the more detailed the grid is, the more difficult the screen is to manage and the more constraints you have. The simplest approach, however, the one with the fewest impediments is best. So don't use an overly or highly detailed grid for your illustration if it's just not needed.

Remember whether made up of three, four, five parts or more, the grid is used in the design and illustration world just as a guide. It's easier to isolate one section of the screen and get to work rather than staring at the entirety of a still-to-be-started full-screen illustration.

Diagonals at an Intersection

There are four points of intersection in a three-part composition. By placing elements that are related to each other on the diagonal line of this intersection, the relationship will increase and the illustration takes on depth and resonance.

Here, placing the antagonist in the upper left and the main character in the lower right more clearly establishes the scene of conflict and opposition. Hostility and rivalry can be conveyed any number of ways, but if you want a more impactful screen, placing it at the diagonal intersection ratchets up the tension.

⊞ Take a Look: Practical Applications

Even if there's a difference in the size of the figures included, characters placed on a wide surface stand out better.

All four points are arranged so that the illustration's key elements are highlighted.

© Tommy Walker Inc. "Silver Rain"

Feeling Marginal

Margin Compositions

Margin composition is a method that intentionally leaves a blank space on the screen. It's a design approach that's often adopted for high-end packaging or designs that require elegance. At the same time, it's an effective mode for capturing a solitary character, a lone wolf who seeks out the margins of society.

Tips & Pointers

COMMENTS

To give the impression of forward motion, a margin is placed on the left to create a generously blank space.

The negative space, or the emptiness surrounding the figures, can speak volumes and is just as important a consideration as the heart of the action.

Things with few surface details or distinguishing elements, such as the sky, can be treated as margins.

The space on the left represents the future. The space on the right is the past.

NOTE

If you're troubled with the size, shape or position of the margin, you can refer to Hinomaru composition, two-part composition or the three-part composition for alternate options.

The right-aligned characters yield the strongest result; when they're left-aligned, the focus is scattered and the impact minimized.

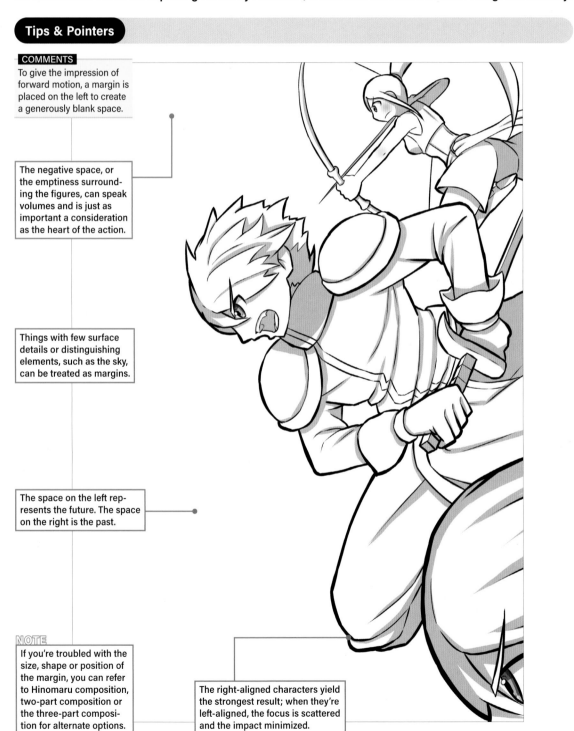

The Basics

Spatial Arrangements

The margin composition allows your work to breathe. Leaving blank space in the direction of the character's line of sight lends the illustration a propulsive force and a sense of momentum, pulling attention along the trajectory of the hero's gaze.

If there are too many elements and the screen is crowded or cramped, this approach allows you to open up space on the screen.

Note that the margin doesn't necessarily have to be white. A blank sky also plays the same role as plain-old white space.

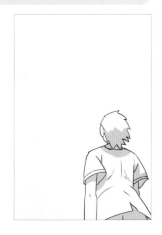

The Direction of the Future

The space on the left side of the character and the space on the right side have different effects.

Japanese comics go from right to left as both frames and pages. Therefore, the direction of travel or the location of the future is toward the left side. If there's space on the left side, it gives the impression of movement in that direction. Conversely, the image drawn in the space on the right side is associated with the past, with points of origin.

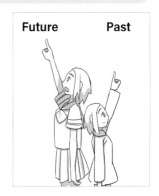

Future **Past**

Daydreams and Memories

❶ contains the image on the left side, and yet the man seems to be thinking about the past, or he's returning from a child's birthday party.

❷ has the image on the right side, where it's clearly evoking past memories. In this way, the impression changes with a slight difference in position, so always think about placement in constructing your drawings and managing the stories they tell.

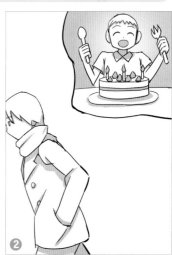

The thought the character's conjuring is on the left as if he's imagining the future.

Here it looks as if the character is recalling the past, as the thought is located to the right, behind the character.

Examples of Margin Composition

Since there's no standard for the size of the white area, it depends heavily on experience and intuition. Advanced users will have a better sense of the kind of spacing they'll need. No matter what, in order to produce better illustrations, margin composition is an approach you'll want to have at your reserve.

As a guideline for placing margins, it's easy to get a balanced margin if you employ two-part composition (page 46), three-part composition (page 50) or the Hinomaru composition (page 34). It's best explained with a couple of examples.

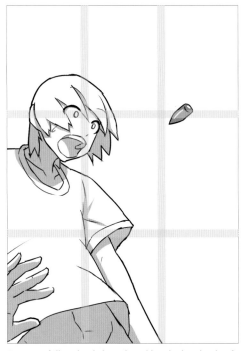

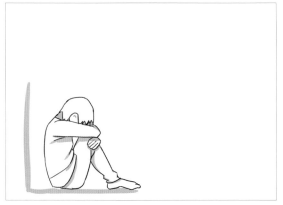

Large margins were used to capture a sense of loneliness and sorrow without relying on specific expressions. Thanks to the exaggerated size of the white space, a sense of blankness and emptiness is conveyed. Large swaths of "blank canvas" reflect the isolation on display, and the larger the range, the more effectively the sense of alienation is conveyed.

A sense of direction is introduced by placing the tip of the bullet at one of the grid's intersection points. An inverted triangle composition (page 30) lends tension to the scene, with the face and chest are placed in the three-part opposition. As the bullet required a bit more space, its position was shifted slightly.

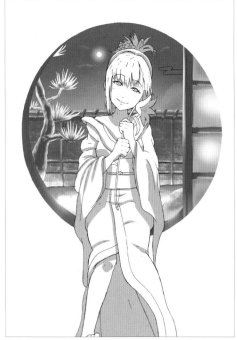

Former lovers passing on the street are inserted here into a three-part composition. The man behind the woman, her new love, is less important, so he's silhouetted and doesn't touch the grid lines. The woman turns to the left and proceeds to the future, her face cut off. The protagonist turns to the right momentarily stuck in the past and unable to move on.

With large margins in the four corners, the background is confined to a circular round window, and the protagonist is placed in a Hinomaru composition for balance.

Let's Get Practical

Power Positions

Similar to the way past and future can be relegated to opposite sides of the screen, oppositions can be staged and framed in the same way, the strong character on the right side and the weaker figure on the left half of the screen.

Japanese manga progresses from right to left, so momentum originates and builds from the right. So, adopting this approach, the right-positioned character is typically the strongest. Conversely, the left position blocks the flow of the action and the narrative, arresting motion and giving the reader a sense of discomfort, defeat or deferral.

Here, the character facing to the right prepares for an attack from the right, defending from the weaker, left side. This is a common principle used in various industries, including video games and animation.

Take a Look: Practical Applications

This is an example of using margins effectively. Thanks to the margins, the motion of waving a sword even when the sword isn't drawn is suggested. The character fills the frame, spreading from right to left, to form this highly defensive pose.

© Student: RE

Framed to Perfection

Frame Compositions

Frame compositions are used to emphasize the protagonist's presence or to add depth and layering to your creations. Just like a framed portrait or painting, the frame concentrates the focus of the viewer and highlights the image within.

Tips & Pointers

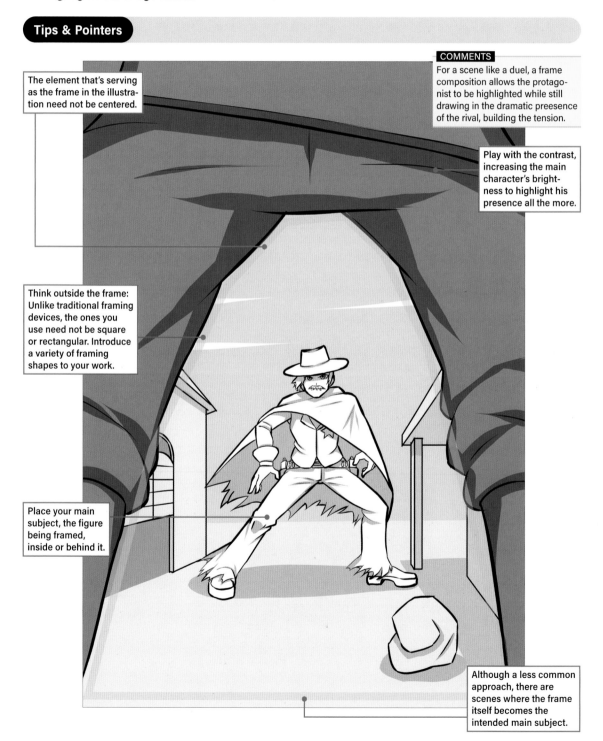

The element that's serving as the frame in the illustration need not be centered.

COMMENTS
For a scene like a duel, a frame composition allows the protagonist to be highlighted while still drawing in the dramatic preesence of the rival, building the tension.

Play with the contrast, increasing the main character's brightness to highlight his presence all the more.

Think outside the frame: Unlike traditional framing devices, the ones you use need not be square or rectangular. Introduce a variety of framing shapes to your work.

Place your main subject, the figure being framed, inside or behind it.

Although a less common approach, there are scenes where the frame itself becomes the intended main subject.

The Basics

Inside the Framework

With your main character surrounded by a framing device, the focus is drawn like a spotlight to the center of the illustration. This approach is also called tunnel composition, because of the tunnel-vision effect it creates. A strong sense of depth and perspective is created simply by placing your main character squarely within the frame.

Tunnels, windows and archways are common framing devices, while in manga the inseam or wide-stance legs of an antagonist are often used, with the antagonist foregrounded and drawn much larger than the main character. The antagonist's looming outsized presence injects an added note of tension into the scene.

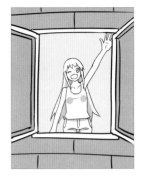

Playing with Placement

Unlike with a Hinomaru composition (page 34), the frame approach frees you from placing your main character or object exactly in the center of the screen. The Hinomaru approach is ideal for putting your protagonist in the spotlight, but as you saw in the section on margin compositions (page 54), a work's power and impact vary greatly depending on the placement and arrangement of the elements. With a frame composition, you can experiment with a variety of positions and placements, with no restrictions, until you find the right one. Of course for even more startling effects, combine the frame and Hinomaru approaches for those moments when even more emphasis is required.

Creating Contrast

In the △ example, the brightness of the frame matches the brightness of the main character too closely. Not enough contrast is created, and it becomes too difficult to focus on the protagonist. Compare the frame with what it's surrounding, adding contrast by playing with light and dark tones. With the ○ example, the framing device is darker while the foal is made brighter and lighter, concentrating the line of sight on the newborn horse. Try playing with contrasting colors or blurring the frame as alternate approaches.

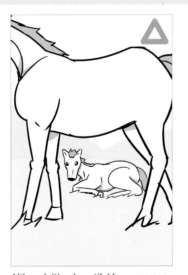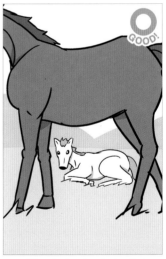

Although it's a beautiful frame composition, the colt is blurred, its presence and importance downplayed as there's not enough contrast between it and the mother's body in the foreground.

By making the framing device darker and the main subject lighter, a stronger sense of contrast is created, making this a more successful example of a frame composition.

Let's Get Practical

Devising the Frame

There isn't a wide range of applications for the frame device, but when you have a scene or scenario where it can be effectively applied, the results are apparent. One challenge is to come up with a fluid and adaptable framing device, one that allows you to make changes. Move beyond the obvious framing devices like archways, portholes and windows. Devise a frame that's less rigid or less conspicuous.

A retro effect is applied here with the blurring of the edges and four corners, but it effectively offsets the subject within.

Here's an example of creating a frame by surrounding the screen with leaves and trees, creating the impression of a clearing in a deep forest.

EXPERT TIPS ●●●

I've Been Framed!

A frame can play several key roles in your illustration. Just as a frame protects a valuable painting in a museum, it plays a similar role in your work. Rather than protecting it, however, it contains and unifies the drawing. Ultimately, the frame stages the work within, underlining the importance of the subject matter all the more.

Just as important, a frame serves as a barrier, a border, a dividing line between the different layers contained in your illustration. The frame serves as a margin and can add valuable white space, as it's called, to the layout. Consider the role of white space in print advertisements. Compare a supermarket flyer, crammed with words and images, versus an ad for a luxury automobile or watch. The large amount of blank space gives the high-end items an added sense of elitism and appeal.

A Frame-Up

Sometimes the framing device seems to be playing the starring role. The basic concept is to place the protagonist behind the frame. However, that arrangement can always be altered or reversed. Make the frame as small and as simple as possible while filling in around it with your eye-catching elements.

For the example, the subject is an isolated fairy-tale princess sick with longing for the outside world. Decorative molding and a carved column fill the frame, while contrasting all this luxury is the simple space opening in the center.

⋂ Take a Look: Practical Applications

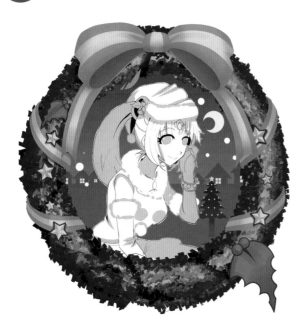

For this Christmas-themed illustration, the characters and backgrounds are placed in a circular wreath frame.
© Tommy Walker Inc. "Silver Rain"

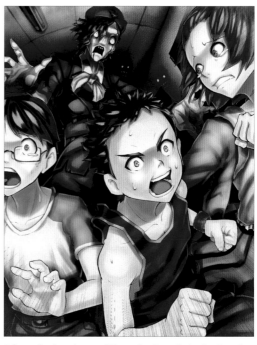

A frame is placed around the main character's ghost, as the others flee into the foreground.
© Kinnoseisha Co., Ltd. "A Scary Story and Scary Place Encyclopedia Near You"

Frame by Frame

Panel Compositions

Panel layout composition adds a unique effect to an illustration, good for explaining the details of a scenario or the narrative arc and development of your story.

Although the manga-like frame effect is one strong way of approaching your subject material, this approach is also ideal for collecting and gathering lots of visual information into a single illustration. It's often adopted for designing the covers of light novels, where as many of the characters and key scenes need to be included as possible. You can also show the passage of time using frames.

Tips & Pointers

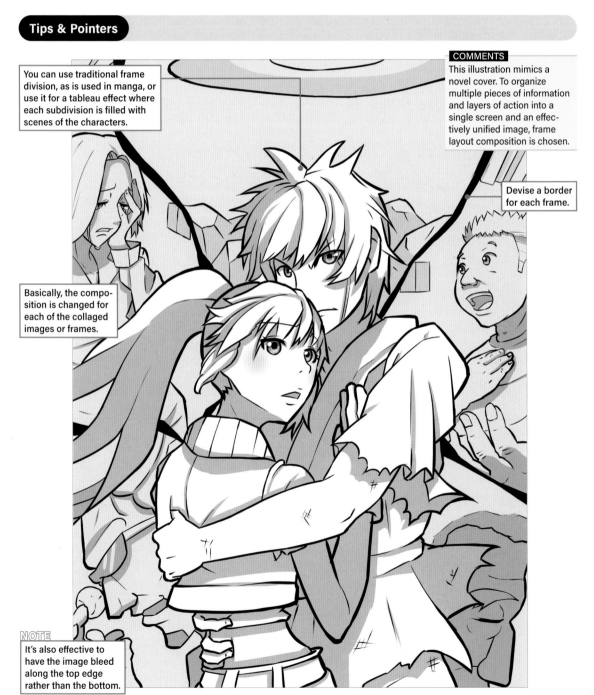

You can use traditional frame division, as is used in manga, or use it for a tableau effect where each subdivision is filled with scenes of the characters.

COMMENTS
This illustration mimics a novel cover. To organize multiple pieces of information and layers of action into a single screen and an effectively unified image, frame layout composition is chosen.

Devise a border for each frame.

Basically, the composition is changed for each of the collaged images or frames.

NOTE
It's also effective to have the image bleed along the top edge rather than the bottom.

The Basics

Frames Per Second

With this approach, the screen is subdivided into multiple frames that can then be filled with detailed tableaus that collectively clarify and explain the scene being presented. It's also an effective way of organizing the composition using the various building blocks of the subdivided scenes. This approach is also ideal for creating bright, pop-art or manga-inspired illustrations.

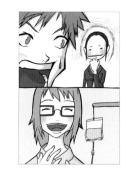

Combining Compositions

Using this multiple-frame format allows you to apply different compositional styles to each of the images featured. From tilting and bird's-eye views to multiple-shot or letter-based approaches, use different methods depending on the situation and the demands of the scene.

Choosing and then producing each of the subdivided scenes is a more challenging proposition than a simpler approach. The increased time and effort will prove worth it, however, when you see the complex, sophisticated charms you're capable of conveying with this approach.

Shift the character to the left as the frame progresses to create a natural flow.

A bird's-eye view offers information and details. Pull in close while still not showing the face obscured by the hat.

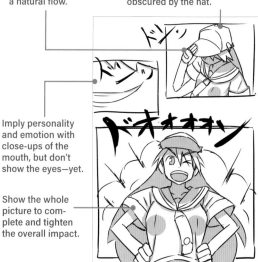

Imply personality and emotion with close-ups of the mouth, but don't show the eyes—yet.

Show the whole picture to complete and tighten the overall impact.

A Style for Every Frame

Each frame is flat and similar in figure △. Although the information is being conveyed, it's not being done so effectively. In figure ○, the screen is subdivided in a more interesting and complex manner. The overall illustration is more effective and powerful as a result.

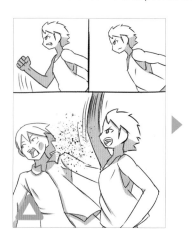

A close-up of the fist signals the intensity and force at play in this scene.

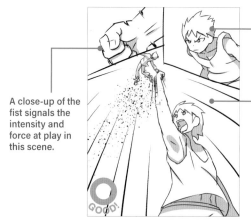

The upper right was changed to a diagonally shaped frame, and the right arm was added to create a bridge and to establish flow to the next frame showing the clenched fist.

With this new configuration, the antagonist's defeated figure effectively fills the empty space. His body flying into the sky relies on diagonal line composition (page 42), connecting the close-up of the fist to its possessor, the main character.

The detailed images here look too much alike and are similarly flat. This is often the case when people who are not used to drawing manga use the frame layout.

In the end, the multiple frames combine into a single, compelling tableau.

Effectively Framed

With frame layout composition, the typical cels or frames used in manga can be dropped in as they are ❶. But the approach also allows you to make unique transformations and reinventions to a single picture (❷, ❸). The frame layout mode is basically a convention of manga, so a vertically oriented screen is more compatible. Depending on the device or design applications you're using, it may not be adaptable to a horizontal screen ❹.

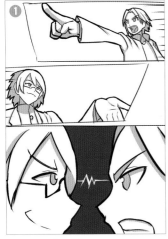

Expressing hostility. To capture a similar and equally matched animosity in the rival, be conscious of symmetry and the overall balance. The main character is placed on the right and the antagonist on the left, following the principles of margin composition (page 54). The edges of the top two frames are slanted to direct and guide readers through the narrative progression to the bottom frame.

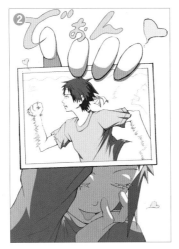

A photograph used as a framing device in the illustration. The influence of the Hinomaru approach (page 34) as well as frame composition (page 58) is noticeable, making the contrasts in character size and movement that much more distinctive.

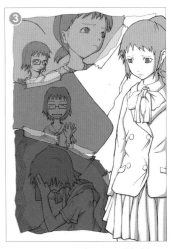

Here, a torn-up and reassembled love letter is the creative basis for the screen's subdivisions. The lonely figure is relegated to the right and the illustration avoids the strict linear progression and clearer explanations of manga.

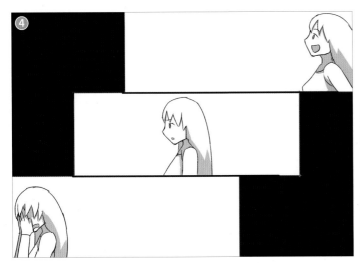

A woman grows increasingly depressed over time. In order to achieve a sense of consistency and balance, the same style of composition is repeated in each of the three divisions. The frames are created according to three-part composition (page 50).

To express the passage of time, move the frame gradually to the right according to the principles of margin composition. The progression also signals that the negative feelings are building by increasing the space behind the woman. Emotions (page 146) and facial expressions (page 150) come into play here, as does the emphasis and interplay of white and black.

Outside the Lines

There's no reason your characters need to be entirely contained within the frame. Although it's a method that is also frequently used in manga, it will be an interesting piece of work if you let the character bleed into the edge of the frame and be only partially shown.

The figure on the right shows only one frame on the screen, but the character is erupting from it. The story takes on an immediacy and dynamism, as the character seems to be jumping out of the screen.

 # Take a Look: Practical Applications

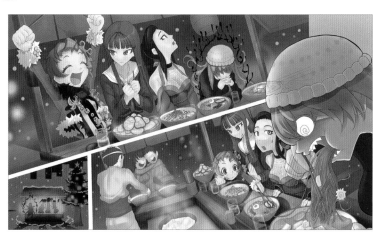

The scene is changed in each portion of the screen as the situation is explained and clarified. A number of compositional modes are used here, including diagonal composition (page 22), the Z composition (page 70) and an overlapping composition (page 78).

© Tommy Walker Inc. "Silver Rain"

This is a collage depicting the Seven Wonders. The screen can be divided into any number of equal parts. Since each of the subdivisions is given equal weight and importance, even if there are many elements, such as group shots (page 114), information can be gathered and presented clearly. In this case, the content changes considerably from frame to frame, but a uniquely unified illustration results nonetheless.

© Confectionery Kimura

To the Letter
Alphabet Compositions

Certain letters of the alphabet can be used as the basis for complex, layered or sinuously shaped drawings. These alphabetic approaches can be applied to a wide variety of scenes and situations as well as improve how you structure your composition and pose your characters.

The Hinomaru composition (page 34), the circle composition (page 38), the Z composition (page 70) and the S-shaped pose (page 124) are just some of the ways of introducing letter-based thinking into your work.

Tips & Pointers

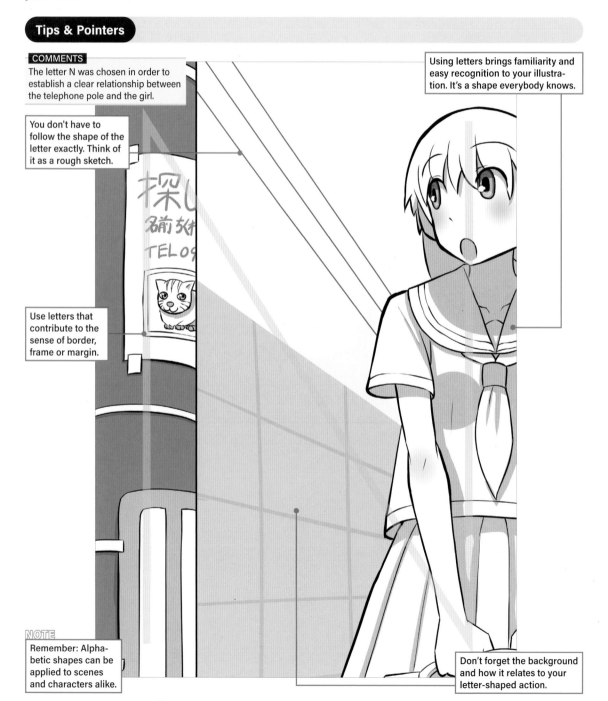

COMMENTS
The letter N was chosen in order to establish a clear relationship between the telephone pole and the girl.

You don't have to follow the shape of the letter exactly. Think of it as a rough sketch.

Use letters that contribute to the sense of border, frame or margin.

Using letters brings familiarity and easy recognition to your illustration. It's a shape everybody knows.

NOTE
Remember: Alphabetic shapes can be applied to scenes and characters alike.

Don't forget the background and how it relates to your letter-shaped action.

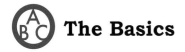 **The Basics**

The ABCs

As we looked at with triangle composition (page 29), the letters of the alphabet are universal symbols, instantly recognizable. Hinomaru composition, circle composition and Z composition are especially effective letter-based approaches.

Not only does the letter shape help unify the composition, it brings a familiarity that will draw in the viewer. Iconic symbols hold great power, and there's nothing more iconic than the letters of the alphabet.

An A-shaped composition really works for this recumbent pair. The wide base of the triangular A stabilizes the field.

Which Letter to Choose

Any letter can be used as the basis for your composition.

You can always change letters while developing and improving your illustration, but it's important to follow that shape. The trick is to match the impression and mood to the letter. A or H, with their wide bases, and L, with its solid bottom border, can be used when you want to introduce a sense of stability. V, with its upward thrust, and D, which is wide and rounded, are recommended when you want to capture movement or a sense of instability, as in the inverted triangle approach (page 30).

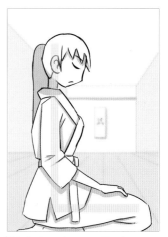

This L-shaped composition is a perfect match for a seated figure.

Exchanging Letters

The figure △ shows the letter I as an ideal match for a character standing upright, but relegated to the left and with no background detail, the illustration is too stark and bare.

Choose other letters to achieve a more complex shape and effect. Here M is selected for the angularity and dynamism it brings to the hand-shaking characters.

When the letters are similar, such as O, Q and C, V and W, or F and E, you can swap one shape for the other with little effort. If you don't get the impression you want, just choose a different letter.

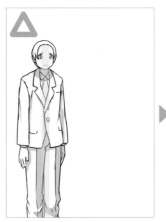

With this simple I-based composition, a sense of loneliness and isolation is conveyed, but little else.

While an M-shaped composition really works here, do you see how H would've been a strong substitute as well?

Overlapping Elements

The letter-based elements can be connected, spread out or the motifs can overlap to create even more complex shapes. You can always adjust, tweak and revise making certain elements stand out, embracing the flexibility and freedom of these alphabetic forms.

A Y composition. Tilt up for extreme momentum.

Here a reverse Q would've worked, but the P perfectly contains and amplifies the action

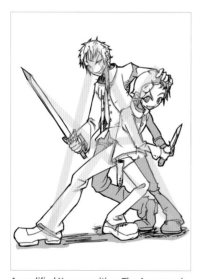

A modified X composition. The A composition is also added to increase the stability.

A combination method using the letters K and L. Even a casual, quieter scene can be enhanced through alphabetic pairings.

Let's Get Practical

Developing Your Own Style

Letter-based compositions are essential to have in your digital illustration toolkit. These universal forms are as elemental as circles, triangles and squares and can be applied to any type of scene or character. The figure on the right is an illustration using a heart as a motif. As a variant of the inverted triangle composition (page 30), it conveys a sense of movement and instability.

To challenge yourself, try combining different approaches. To add a sense of momentum and action, turn to the diagonal approach (page 22) or to better organize and control space in your illustration, try a three-part composition (page 50).

Take a Look: Practical Applications

An N composition. Letter-based approaches help tighten and unify, even if your illustration has a more restrictive frame and a limited scope.

© Adrenalyze Inc. "Investigator Runlan"/Seiya Fujiwara

It's an L composition. Or is it a J composition? How about a D composition? Either way, the unity is strong here.

© Tommy Walker Inc. "Silver Rain"

Guiding the Viewer's Eye

Z Compositions

Z composition is great when you want to control and guide the movement of the viewer's gaze. You can convey a lot of visual information by simply arranging the elements into a Z shape. It's a common lay-out used in magazines and advertisements. Keep your key elements along the letter's shape, making the space surrounding it less of a focus.

Tips & Pointers

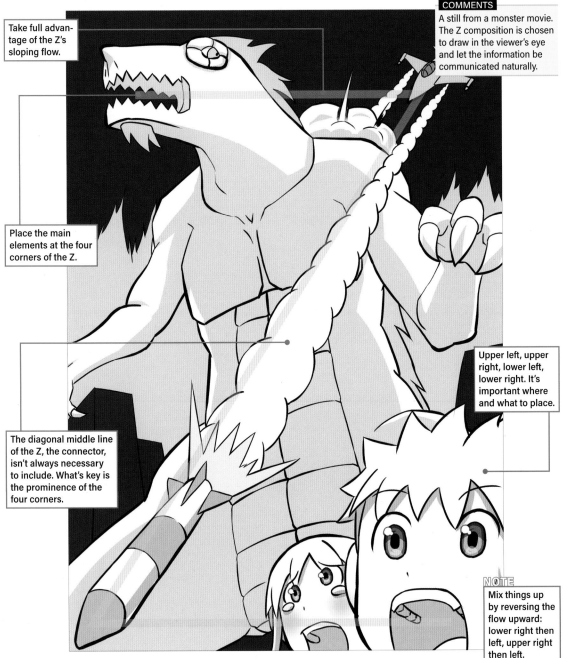

Take full advantage of the Z's sloping flow.

COMMENTS
A still from a monster movie. The Z composition is chosen to draw in the viewer's eye and let the information be communicated naturally.

Place the main elements at the four corners of the Z.

Upper left, upper right, lower left, lower right. It's important where and what to place.

The diagonal middle line of the Z, the connector, isn't always necessary to include. What's key is the prominence of the four corners.

NOTE
Mix things up by reversing the flow upward: lower right then left, upper right then left.

The Basics

Z Composition

Of all the alphabet compositions (page 66), the Z brings motion, flow and unity to the screen, taking advantage of the natural flow of the human gaze. The Z composition guides the gaze through an often detailed scene. Illustrations based on this letter can really pop while lingering in the mind, as the four key corner points add up to a memorably motion-packed drawing.

The Gutenberg Diagram and Z Composition

Z composition draws attention to the four corners. These four points do not all work the same way, and their importance varies depending on where they're placed. This rule is called the Gutenberg diagram.

The human line of sight flows down a page or screen in the form of Z from the upper left ❶ of the introduction to the lower right ❷ through the upper right and lower left.

The upper right and lower left in the middle of the screen are not the best places for something important or conspicuous. This is the area the line of sight passes through, so if you place the elements necessary for the illustrations here as well, the balance of the entire screen will be improved and the information will be conveyed clearly and smoothly.

The top left is the most important area for drawing in the gaze ❶. Place your most visually appealing element here.

Location, Location, Location

In the △ figure, elements are arranged at the four points, but with little awareness of the importance of placement. Because the main character was put in the lower right, the gaze doesn't flow smoothly through the illustration, and a sense of imbalance emerges.

Figure ○ arranges the elements according to the Gutenberg diagram. The information has been smoothly arranged and conveyed, the gaze successfully guided along the letter's form.

Of course you don't have to rely on the Gutenberg diagram, when creating a Z-based composition. Depending on the illustration, you may want to place important motifs in the upper-right and lower-left corners, or you can shift the location on purpose for a mysterious impression.

The arrangement of important elements is disjointed, creating an unintended sense of imbalance and impeded flow.

Having the layout changed according to Gutenberg diagram, the flow of the gaze becomes smoother, making it easier to convey the information you want to.

Ⓩ Practical Composing

How Big Is Your Z?

It's important to pay attention to the size of Z in your illustration. Large or small, the size affects the overall impact of the work. Of course, you can express depth by applying perspective to the Z shape. Just be careful not to make your Z too small. Too much white space surrounding it creates an exaggerated border and the illustration won't take full advantage of the Z's flow and shape. Combining multiple composition models here might be the answer, just be aware that a four-point shape like the Z might not be entirely compatible with three-part compositions and shapes (page 50) placed closer to the center.

Here with the strict three-part division, the role of a Hinomaru composition (page 34) is exaggerated.

A Z-shaped design is most effective when applied boldly and dynamically.

EXPERT TIPS ●●●

Illustration and Design

There's a very deep relationship between design and illustration, as each aspect is intended to produce art and images that are conscious of the viewer. In both of these worlds, different approaches to composition come into play. The word *"design"* is derived from designate, so the artist assumes control of the creative space, assigning the key elements a position. It means making an effective plan to convey information to the viewer and expressing it in a clear, concrete way. Fine art/painting, illustration and design all subscribe to these rules.

In particular, the Z-based composition is very useful for professional artists. For illustrators of posters, books and magazines, collaboration with designers is a must. Having knowledge of each other's fields is a huge advantage and will only improve your work in the long run.

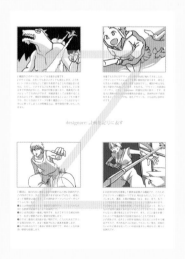

Zigzag Progressions

The Z composition or Z pattern, as you'd expect, follows the strict progression of that letter. Viewers start in the upper left, shift horizontally to the upper right, then diagonally to the bottom left, followed by another horizontal shift to the lower right. The Z composition is sometimes called the reverse-S composition or pattern, which suggests more of a flowing, sinuous path than the rigid, straight-lined shape of the Z. Like the Gutenberg diagram, Z compositions start and end in the same places, while still passing through the middle field of vision. An illustrator still places the important details and the key information along the pattern's path. This composition model is good for simple designs with only a few elements that need to be highlighted, so it's a great choice for telling your story or advancing the narrative.

 # Take a Look: Practical Applications

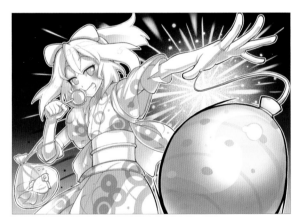

A Z-based composition reflecting the influence of the Gutenberg diagram.
© DeNA / Hacka Doll THE Animation Production Committee

A Gutenberg diagram, starting with the face of the protagonist and ending with the information that a thief is trying to steal dumplings. See how easily the information is conveyed?

A Way to Achieve Balance

The Golden Ratio

The golden ratio is a term used to describe how elements within a piece of art can be placed in the most aesthetically pleasing way. But it's not just a term, it's an actual ratio that can be found in many pieces of art. Mona Lisa's famously enigmatic likeness is constructed along the lines of the golden ratio. So is the game character Sonic. The golden ratio is used for "beauty shots" or to bring harmony and balance to the screen.

Tips & Pointers

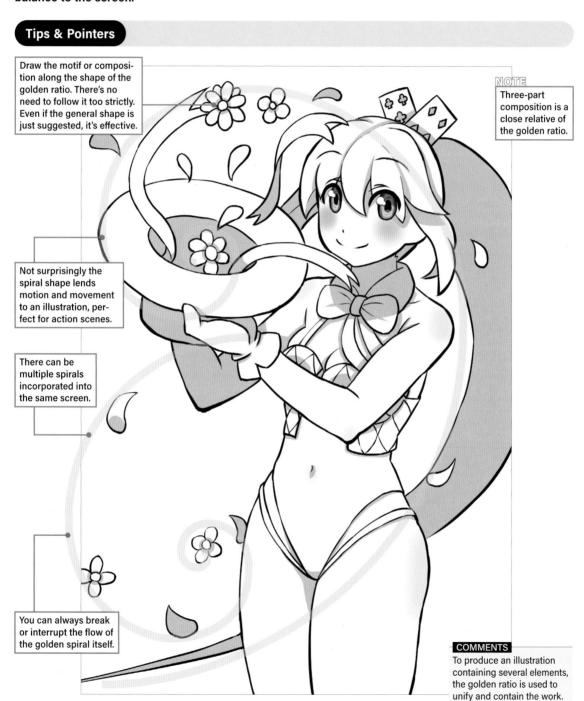

Draw the motif or composition along the shape of the golden ratio. There's no need to follow it too strictly. Even if the general shape is just suggested, it's effective.

Not surprisingly the spiral shape lends motion and movement to an illustration, perfect for action scenes.

There can be multiple spirals incorporated into the same screen.

You can always break or interrupt the flow of the golden spiral itself.

NOTE

Three-part composition is a close relative of the golden ratio.

COMMENTS

To produce an illustration containing several elements, the golden ratio is used to unify and contain the work.

The Basics

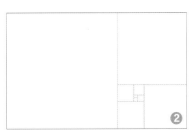

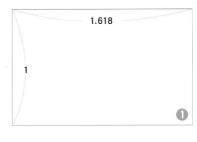

Golden Rules

The golden ratio is, strictly speaking, 1:1.618. An easy-to-understand graphic representation of this ratio is called a golden rectangle, which is a square stretched 1.618 times on the left, right or top side ❶.

This golden rectangle can actually be subdivided into countless squares ❷. It's basically an aggregate of squares, summoning the solidity and balance of the form.

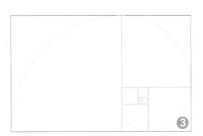

Connecting the corners of each square with diagonal lines creates a spiral shape. This is called the golden spiral ❸. Character design as well as composition and layout design that's intended to be beautiful or appealing are often created according to the golden spiral.

The Most Beautiful Sketching Rule in the World

Using the golden spiral makes it easy to create attractive, visually appealing works. Just remember you need not incorporate the shape in its entirety. It's fine if just part of the image or subject is along the spiral or slightly removed from it.

 Remember that you're not limited to a single shape or placement. The spiral can be vertical, horizontal or upside down. Even though it's easy to apply, the spiral shape is complicated, so that's why only a portion of and not the entire shape is relied on.

 Three-part composition (page 50) is sometimes called the golden ratio or golden division. If you divide the golden rectangle in three, the line passes close to the dividing line used in the golden ratio.

Vertical or horizontal placement

Let's Get Practical

Using the Golden Spiral

The golden spiral can be applied to both composition, the structure of your scene and to poses, the placement and positioning of your characters.

Used on character design. A drawing of Death fits along the spiral. The shape brings unity, movement and flow to the work.

You can use more than one golden spiral in the same illustration. In the example, four have been used. You can use the shape as it is to suggest a cloud, or integrate just a portion of it, as in the profile. Mountains can be drawn along a curve, grouped with trees, or dotted along the golden spiral like the sun and birds.

EXPERT TIPS ●●●

Nature's Golden Spiral

The golden ration isn't reserved just for the art world, it's a shape often found in nature. Many plants follow the shape of the golden spiral. Sunflowers, pinecones, ferns, the spirals of a conch, even typhoons and galaxies mimic the shape of the golden spiral. It became a hot topic in Japan in 2016, when it turned out that the shape of Kyushu, the southernmost of Japan's main islands, is also in line with the golden spiral.

Golden Spirals That Leap off the Screen

The golden spiral doesn't have to fit onto the entire screen. It can be broken up, subdivided, twisted and torqued in any way you please. There are some restrictions, as the screen becomes more complicated by breaking the golden spiral into smaller pieces or parts. Try combining it with other compositional approaches or playing with its size or placement, enlarging or reducing it or putting it at a slant.

With a little more restriction, breaking the golden spiral makes the screen more complex. Although some professionals use the golden ratio rarely or sparingly, it's an effective method to lean on. Try increasing the size of the golden spiral, reducing it, obliquely, or combining other compositions.

Take a Look: Practical Applications

Two golden spirals are used at the top and bottom, and they converge on the character and the cat, respectively.

Two golden spirals are used on the left and right.

It's All in the Perspective
Overlapping Compositions

Overlap composition is a technique where the image or subject in the front overlaps or intermingles with the one in the back. This is a great choice for illustrations highlighting depth and perspective and the interplay of the foreground and background.

Overlap composition is a term used for digital illustration; it's different from video technology overlap. Here overlapping means the layering and interconnection of key points in the composition to create a greater and potentially more dramatic sense of depth.

Tips & Pointers

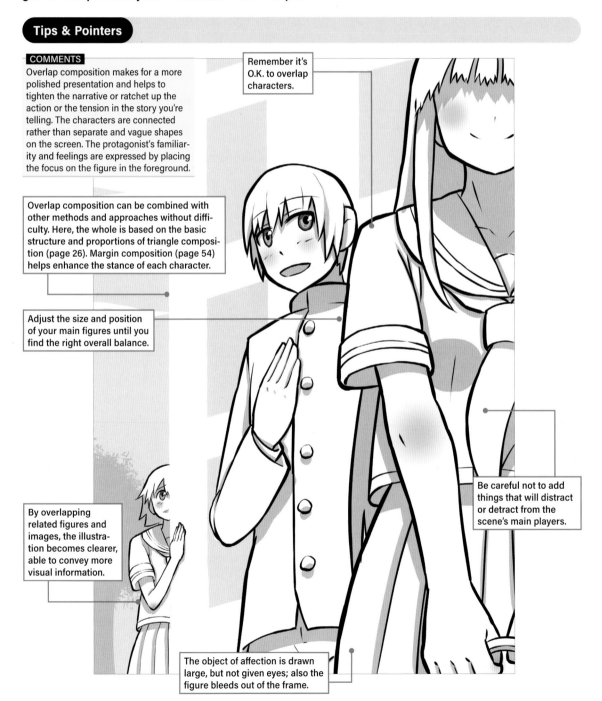

COMMENTS
Overlap composition makes for a more polished presentation and helps to tighten the narrative or ratchet up the action or the tension in the story you're telling. The characters are connected rather than separate and vague shapes on the screen. The protagonist's familiarity and feelings are expressed by placing the focus on the figure in the foreground.

Overlap composition can be combined with other methods and approaches without difficulty. Here, the whole is based on the basic structure and proportions of triangle composition (page 26). Margin composition (page 54) helps enhance the stance of each character.

Adjust the size and position of your main figures until you find the right overall balance.

By overlapping related figures and images, the illustration becomes clearer, able to convey more visual information.

Remember it's O.K. to overlap characters.

Be careful not to add things that will distract or detract from the scene's main players.

The object of affection is drawn large, but not given eyes; also the figure bleeds out of the frame.

The Basics

Overlapping Realities

By including two or more elements, one in the front and the other in back, you can easily create a sense of depth by overlapping them.

Aerial perspective are one obvious way of expressing depth, but with overlapping composition, depth can be suggested simply by layering the main subjects of your illustration.

Many people are conscious of the Y-axis representing the vertical space on the screen and the X-axis representing the left-right space, but those who are just starting out as illustrators can begin to explore the dimensionality of the Z-axis and the way it adds space and depth.

The Layered Look

Overlap composition is effective for both characters and the background. An intervening object can be overlaid onto your protagonist, blocking out part of her body, while adding depth and dimensionality to the drawing.

In digital illustrations, you can adjust the balance of the placement later, such as shifting the position after you've had a chance to assess what you've created.

Stackable Sizes

In figure △, a floral motif is superimposed onto the figure. However, it's too big and darker than the character. This is fine if a flower is your main character. In this case, make the overlapping elements smaller, don't obscure the face, make the color lighter than the main character and add a subtle blurring effect. The depth of the image will increase further as if it was blurred (page 118).

The flower and the leading lady have switched places in this less than successful rendering, and the blooms have upstaged the main character.

By reducing the presence of flowers, the character was able to emerge as the central presence. After drawing, make adjustments to complete the work and add that extra layer of polish.

⊘ Let's Get Practical

Devise an Overlapping Motif

With this approach, it's easy to express depth by overlapping elements, such as patterns or related images.

While filling the entire screen effectively with the main character, the illustration still conveys a sense of distance and speed. Diagonal line composition (page 42) is introduced to increase the sense of motion and flow. A tilted point of view (page 8) is also used to make the rendering even more powerful. Clearly, overlap can be easily combined with other composition models.

It's a composition often seen in female-themed manga. The parts that can't be shown are hidden by the leaves in the foreground, adding a humorous note to the image.

EXPERT TIPS ● ● ●

What Is an Overlap Composition?

In my experience, overlapping content is easy to do. Think of your favorite films or paintings you admire and consider how layered elements come into play.

Take the basic template of your illustration and then consider what can be superimposed onto it, to add to the depth, complexity and visual intrigue. Eventually, overlap will become a natural or intuitive part of your work.

In addition to layering, the Z-axis and the depth it introduces can be an illustrator's best friend. Depth technology is indispensable for improving your illustrations, so learn to wield its power as much as possible.

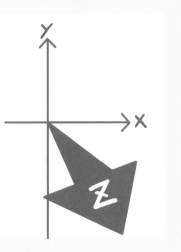

Let's Be Transparent

Overlap compositions need not blot out or eclipse part of your character or main subject. For example, if you add a transparency effect, you can create overlap without obscuring your main character.

For illustrations, transparency is very important. Even with a pencil drawing, more advanced artists add a transparent vinyl effect to particular elements. In other words, adding these layers and embellishments is the sign of an advanced sketcher. With digital illustration, you can easily add translucent effects just by adjusting the transparency.

 # Take a Look: Practical Application

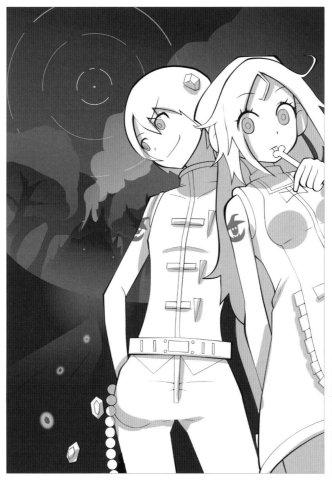

This is Hansel and Gretel. In addition to emphasizing the relationship between the two, the movement of the screen and how the characters are supporting each other is expressed by tilting one side and altering or upending the balance.

Cropping and Trimming

Cut-Up Compositions

Cropping or trimming is one of the techniques that allows you to modify a finished work. The option can be applied when you want to change the composition or the main character. In the game industry, one-shot full-body drawings may be trimmed and converted to close-ups, medium close-ups, medium long shots and so on. Other than these special cases, it's often used in general to tweak and refine the final impression a work gives. Although it's a technology that's unique to digital, it can be applied to any number of design and illustration tasks.

Tips & Pointers

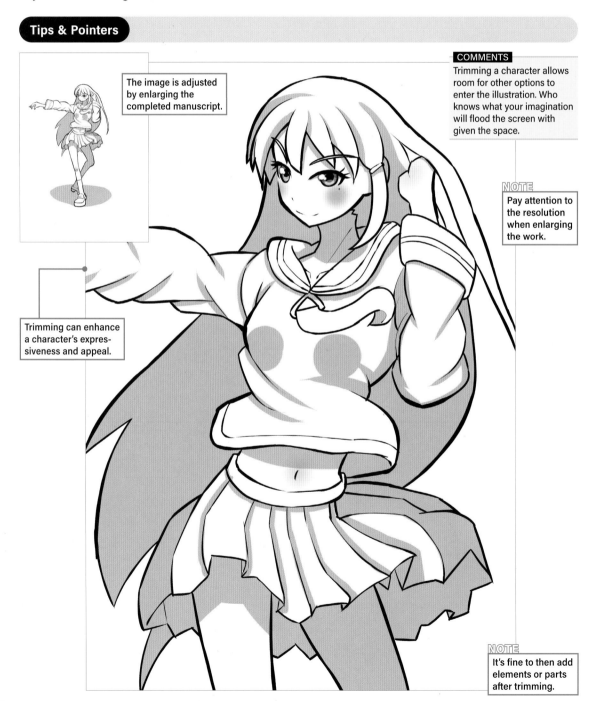

The image is adjusted by enlarging the completed manuscript.

Trimming can enhance a character's expressiveness and appeal.

COMMENTS
Trimming a character allows room for other options to enter the illustration. Who knows what your imagination will flood the screen with given the space.

NOTE
Pay attention to the resolution when enlarging the work.

NOTE
It's fine to then add elements or parts after trimming.

The Basics

Trimming Techniques

Trimming refers to the process of adjusting the work to improve it and finish it off. Sometimes the character's too big or too small, and it doesn't give the expected impression, or it started as a medium shot but was later changed to a medium close-up. At that time, you can change the composition by rescaling and adjusting it. If you make one of the two characters larger, then the protagonist is established with the other one sliding into the supporting role. It's a very useful technique if properly applied and is especially compatible with margin compositions (page 54).

In addition, there are people who trim and colorize at the rough sketch stage. Painting or color will change the illustration's impression overall, and you'll eventually need to adjust the size and position. At that time, the trimmed part is not colorized, so if you reduce the picture, the unpainted parts need to be created onscreen. Since that part needs to be added, trimming is basically recommended after you've completed.

Before Trimming

Trim Time

Figure △ makes use of a tilted angle (page 8) and the Hinomaru composition (page 34) so the main character stands out. However, it's not a strong image, so the character was enlarged, the margins trimmed, and the composition changed to fill the screen. As a result, diagonal line composition (page 42) was established with the body and the sword as well as the tilt.

Even if the trimming performed is slight, minor enlargements and fine adjustments can in the end add up to a lot.

Before Trimming

The Right Resolution

Trimming is based on expanding the work. Enlarging the image makes the image less focused, less sharp (see the appendix "How to Create Data" on page 171). The more it's enlarged, the more the image will degrade, and the more the image is repeatedly enlarged, the more deteriorated it becomes.

Trimming is based on enlarging the work. Eventually, if it's overmagnified, the image will deteriorate. Since image degradation is reduced when zooming out rather than enlarging, first draw an illustration with a size (the same ratio) that's several times larger than the expected finished size. Then the image will degrade less when you adjust it. Also, you should zoom in and out once. First, make a copy of the original image, try scaling it repeatedly if needed, and if you find the ideal trim as a result, you only need to scale it once again so that the original image is the same as the trimmed one.

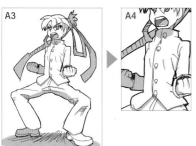

Since the size of the original image can be reduced, there's almost no loss of image quality.

The ideal trimmed and finished composition. Drawing larger than the target size in advance gives you flexibility down the road to reduce and revise, so try and make it a habit.

Let's Get Practical

Cut It Out

Trimming and cropping characters or any element at the edge of the screen can open up a greater range of expression in your work. Opening up space on the screen allows new ideas to enter. Recropping your drawing, trimming and reframing the images is also an effective way of introducing intensity, motion and flow.

By cutting off parts of the legs, as shown in the O figure, you increase the impression of forward motion, and the viewer can imagine the action that extends offscreen and beyond the frame.

Some starting artists can't balance a body without drawing the whole figure first.

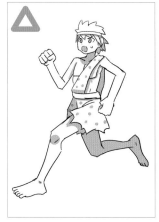

A runner floats on a blank field. Let's make it a little more interesting.

Trimming and cropping tightens the frame, increasing the image's intensity and appeal.

It's recommended to search for the most effective means of trimming, reducing and cropping by drawing first with a one-shot approach and then enlarging it. As always, be careful with the resolution.

Just a Trim

You can change a character's impact or presence through trimming or cropping. Also, if it yields a better image, you can always change the horizontal screen to vertical.

The character in front is large, so it's clearly established he's the protagonist.

Drastically cutting off a portion of a large, foregrounded character reduces his presence. As a result, the size and thus importance of the character in the back is increased. The gaze is turned toward the young woman in order to connect the two characters and layers of the scene. In addition, the screen is changed to vertical, because it can be trimmed or manipulated more effectively and there's no extra margin.

Reduce and Add

Beyond cropping and trimming, consider medium close-ups and medium long shots. If you're not satisfied with the result, you can reduce the completed illustration and add missing details to the necessary places.

Trimming, cropping and reframing are effective techniques for digital illustrations, so if you want to improve your work, incorporate these options.

It's drawn with the intention of then cropping it, but sometimes it's better to draw the whole body instead.

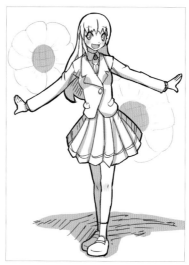

Reduced, the whole body has been added. Including the background and the shading effects results in a gorgeous image.

Inverted Positions

Changing the character layout in the final stages can have a significant effect on the finished work. You can also flip or invert the image to see the difference it creates.

If you rely too much on these features, you may drift too far from your initial intent, but making final adjustments will improve your work. Since it's a technology unique to digital, learn to take full advantage of it, especially in conjunction with margin composition (page 54).

Tilted to the right, the side of the screen often associated with the past.

In the reverse image, the tilt is now to the left side, the character tipped toward the future.

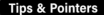 Focus on the Face

Close-Ups

The close-up focuses on the face and is used to establish a direct emotional connection with the scene and character. It's also effective in establishing intensity or framing and presenting a powerful presence.

The close-up is the most commonly used shot in television and film. For the immediacy and emotional pull it creates, it's easy to see why.

Tips & Pointers

COMMENTS
To capture a madman's intensity, a close-up is chosen.

Here the half-face shot is chosen, more effective than showing the entire expression.

Depending on what you're going for, the closer the camera or viewer is, the more effective in making the image grippingly realistic.

NOTE
The impression given depends on the angle of the face.

Because the face is drawn large, pay extra attention to the features and expression.

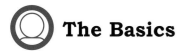 The Basics

The Upshot on Close-Ups

The close-up is a composition placing the face squarely in the center of the screen. It allows your skills at rendering detail and facial expression to shine. Since the character's face is pushed to the forefront, emotional intensity and impact are as well. It's a risky composition that can devolve into caricature, but when successfully rendered, it gives your work power and immediacy.

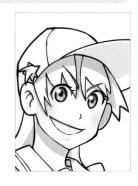

Be Careful with Facial Expressions

The close-up is a relatively straightforward composition finished off with the details that bring appeal and recognition. Make the face as defined as possible, carefully adding in the expression and features to make your character a unique creation.

In addition, the larger the face or the closer the camera approaches the face, the number of fine details evident increases, the contours of the lines, folds and creases. This is a technique often used for animated close-ups.

Slightly increase the level of detail you bring to the hair, eyelids, eyelashes and clothes. Adding bags under the eyes, nostrils and lines along the upper and lower lips can make the face more realistic.

Close to the Edge

Figure △ is an example that doesn't make full use of the close-up's advantages. This is an approach often taken by beginners.

With the fall of the hair, the close-up suggests a circle composition (page 38). Giving the face a roughly circular shape leads to a more attractive result.

Vaguely depicted, with blurry margins, a lack of shadow and a barely defined neck, this is a less than successful attempt at harnessing the close-up's power.

A dynamically appealing close-up with shading included and color added to the cheeks. Also extending the figure beyond the edges of the screen references the world of the character and her story unfolding outside the frame.

The Angle of Approach

It's important to be particular about the angle and facial expression when working with close-ups.

For example, the face with the most appeal and impact is the full-frontal face ❶. There's no coyness or concealment involved, just a bright and smiling visage. Symmetry is essential for this angle, but it's O.K. even if you add an eyepatch or an asymmetrical hairstyle. It's easy to make a composition flow better with the choice of hairstyle.

The oblique close-up is suitable for conveying slightly more complicated emotions than the front-on view ❷. An upturned profile can seem less appealing, but it's suitable for conveying strong feelings (such as sadness) to viewer and readers ❸.

It's also possible to convey the expression more impressively by tilting the face ❹. The effect of the diagonal line can add energy and vivacity to the character.

A straightforward close-up. The hair also takes advantage of the circular shape, and over all the image expresses gentleness and honesty.

A character with an obliquely viewed face. It appears that she's in a bad mood or distracted by worry.

With this profile, the cold eyes convey a strong sense of anger intensified by cutting off the image on the left.

An angled face conveying cheer and warmth that the winking only enhances.

 ## Let's Get Practical

Use Composition and Accessories

You can express a feeling of pressure or intensity with a low-angle shot (page 8), or you can convey coyness and charm or a downturned expression with a bird's-eye view (page 12). You can also crop it at the edge of the screen. Concealment injects an element of mystery and surprise, conveying to the viewer that not all is yet revealed. Mental instability or cruelty are two emotional modes especially suited to this approach. There are many moods and impressions you can capture depending on your ideas and devising.

Sketched from a slight bird's-eye view, this illustration captures a lack of confidence. The same effect can be achieved by directing the face downward.

Expressing embarrassment with sweat. Cropping the edges gives the impression of trying to hide the embarrassment, emphasizing it all the more.

Take a Look: Practical Applications

A low-angle shot of a character's gaze conveys the sense of looking down on someone.

© Student: RE

A square-shaped face is a good match for a solid and strong personality.

By adding light reflection to one lens and concealing the eye, the character assumes a mysterious, enigmatic quality.

© Student: RE

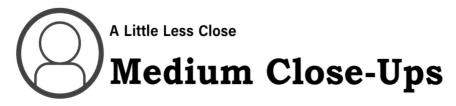

A Little Less Close
Medium Close-Ups

The medium close-up is commonly used for portraits. It lends stability to the image while still offering a direct emotional connection with the character. It doesn't offer you a lot of room for introducing motion or action, but arm or hair motion can be introduced to enliven the scene.

Tips & Pointers

It's easy to turn this into a triangle composition (page 26).

COMMENTS
A medium close-up is often used in video games. It allows you to devise poses and facial expressions to convey the character's personality and emotions.

A hand raised to the face or holding an object adds to the expressiveness of the image.

Be aware of how emotional expression extends into the shoulders and even the hair.

Find the right point where to crop at the bottom.

NOTE
The frontal view is chosen, as aerial or low-angle shots are a little difficult to use in medium close-ups.

The Basics

Medium Close-Ups

A composition that focuses on the upper torso and head, the medium close-up is often confused with the medium shot (page 94).

In case of the medium close-up, the face-to-shoulder area is the target. The face is prominently on display, so it's easy to convey emotional detail and immediacy. It also gives you room to add glimpses of other parts to embellish the scene. The image also forms the ideal triangle composition, with the base fitting on its shoulders with the apex at the top of the head, giving the illustration a strong sense of solidity and stability.

Tips for Using Medium Close-Ups

Since medium close-ups don't include the whole body, the option doesn't offer much flexibility in terms of motion and movement. Also be careful with the depiction of the shoulders, don't forget their role in aiding expressions and conveying emotion. Shoulders are raised when angry, lowered when depressed and rise sharply when someone is surprised. You can do the same with hair. When portraying an angry character, you can convey the character's emotions by having the hair hang down when the character's depressed or having it stand on end when he or she is surprised.

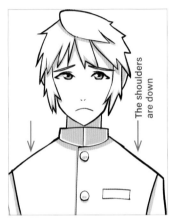

The shoulders are down

Enhancing Emotional Expression

Figure △ is a medium close-up that captures surprise. The facial expression is certainly surprising, but it seems that other elements can be included to convey a little more emotion. Figure [○] conveys a sharper, more amplified sense of surprise.

By raising the hair and shoulders, the sense of shock is intensified. Both close-ups and medium close-ups feature large-faced figures, but you can't rely solely on facial expressions. So consider the other ways emotion is conveyed and how your story is told.

A typical wide-eyed and open-mouthed expression of surprise. The sense of shock is conveyed but it could be captured more effectively.

By integrating the shoulders and hair into the expression, a more complete, fully expressed sense of surprise is achieved. It's more effective when combined with the hand gestures described in the next section.

Medium Close-Ups in Motion

With medium close-ups, facial expressions can be combined with poses using arms and hands. Hands and hand gestures naturally play a part in expressing emotions, so use them to expand the range of a character's emotional expression.

The crooked arm captures the sense of stress and irritation. In addition, the body is placed on a slight diagonal, and the arms create the other axis of an X composition to add movement.

A drill-sergeant type. Since the character isn't angry, there's no need to raise up the shoulders that much, but to suggest strength, the fist and muscles are added.

A classic pose conveying timidity. While fists pair well with bigger emotions, fingers express subtler, more delicate moods.

The thumbs-down gesture is the perfect addition to this character trying to provoke an opponent.

Let's Get Practical

Time to Accessorize

Use accessories as well as other compositional approaches to enhance your illustrations.

The figure in ❶ reflects overpass composition (page 130). It's effective when adding more impact to a medium close-up. In addition, a ten-gallon hat is used to create an inverted triangle silhouette. It's also possible with a witch hat or a double-sided spear. The inverted triangle silhouette is suitable for bizarre and quirky characters.

Figure ❷ offers a comical mad scientist complete with flask. By widening the arms, triangle composition is more clearly established and the illustration overall is more organized.

Depending on the application, some composition models work well with medium close-ups, but for game graphics applications, low-angle shots, aerial views and overpass-influenced approaches are generally not suitable.

Take a Look: Practical Applications

The low-angle view can be used effectively, especially in high-pressure situations.

© Student: RE

By adding the pointed hat and the extended "enchanted" finger, the aura of mystery and magic is enhanced.

© Student: RE

Upper-Body Focus
Medium Shots

The medium shot, like the medium close-up (page 90), is another standard approach to portraits, and similarly establishes stability and emotional connection.

This approach can convey and express a wider range of emotions and elements than the medium close-up, making it easier to work with and manipulate.

Tips & Pointers

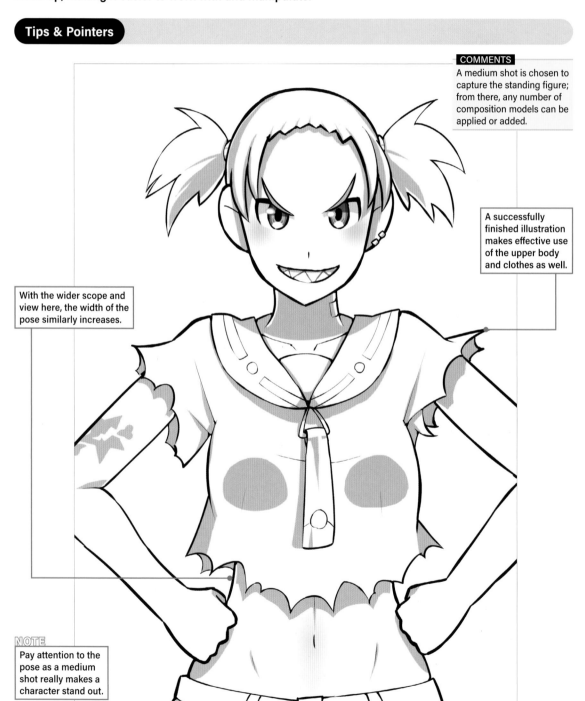

COMMENTS
A medium shot is chosen to capture the standing figure; from there, any number of composition models can be applied or added.

A successfully finished illustration makes effective use of the upper body and clothes as well.

With the wider scope and view here, the width of the pose similarly increases.

NOTE
Pay attention to the pose as a medium shot really makes a character stand out.

The Basics

In the Mid-Range

The medium shot typically takes in the view from the lower back or below the waist to the top of the head. The face is made smaller than with a medium close-up, and there are more extraneous elements to add in, but the shot brings just as much emotional immediacy. Since arms and hands are almost certainly included and the waist can be used, the figure achieves a wider range of emotional expression. Motion, movement and flow are also easier to convey. Triangle composition (page 26) is a possible pairing, but the bottom is often narrower than with a medium close-up, so there's less stability established. Still, over all, it leads to a balanced composition.

Tips for Medium Shots

Basically, the same "rules" and freedoms that come with close-ups and medium close-ups apply to medium shots. As a wider scope is at play, however, you need to develop a compelling pose for your character.

The limit is very large for close-ups and medium close-ups, but when it comes to medium shots, it will be relaxed considerably. The impact of the composition itself will decrease accordingly, so it's necessary to devise a pose to make up for it and to develop a scheme for the composition.

In addition to being able to express both hands naturally, the upper body can also be depicted. Take advantage of these increased choices. It's also easy to add movement with the addition of a jacket or cloak. Hair can also be extended, even down to the waist. Look at the section on hair and clothing (page 142) for details.

Making Changes

Figure △ does not take full advantage of the medium shot with its rigidly posed, stock-straight figure. Still the impact of the face is strong, and the sense of reticence comes through in the simple pose. But when it comes to medium shots, more dynamic poses stand out. Use the entire upper body, such as hair and clothes, to create more attractive positions and to add personality to your character.

This is what people who have recently attempted the medium close-up often do. The field of vision has increased, drawing even more attention to this lackluster, unambitious pose.

By introducing new elements, it becomes even more appealing.

Don't Waste the Waist

A big advantage of the medium shot compared to the close-up and medium close-up is that the waist can be included. By using the waist, you can twist or bend the pose.

The fact that you can use your waist means that you can use a contrapposto pose (page 120). The medium shot is a composition that works well, from stylish poses to battle depictions.

The medium shot is a composition that can beautifully express the contrast from the chest to the waist and the buttocks.

© Tommy Walker Inc. "Silver Rain"

Contrapposto can be used effectively because it draws in the torque of the waist.

The medium shot often locates the bottom border near the waist, so an inverted triangle (page 30) can be created. Long hair, difficult to integrate into a medium close-up, comes into play here.

© Tommy Walker Inc. "Silver Rain"

Torsion and twisting create the feel of movement, motions that can only be done with the waist.

Let's Get Practical

Scenes with Two or More Characters

Close-ups often don't produce an impact unless they're drawn unusually large, and medium close-ups can take up a wide screen because of the character's shoulder width. It makes it difficult to put one or more characters on one screen. With the medium shot, it's easier to feature two or more characters. The same applies to the medium long shot or three-quarter shot (page 98).

Some games show two or more characters even in medium closeup, but with medium shots and medium long shots, where the width of the pose increases, the interaction between the characters immediately becomes more intense and emotional.

Take a Look: Practical Applications

A medium close-up would be difficult to pull off here; instead use the medium shot to accommodate the forward-leaning posture bending the waist.

© Tommy Walker, Inc. "Endbreaker"

With a medium shot, it's easier to put large weapons on the screen. It also makes inverted triangle composition easier to introduce and gives you the freedom to trim

© Tommy Walker, Inc. "Endbreaker"

Medium Long Shots

The medium long shot is another standard approach to portraits, offering stability to the scene while affording a range of motion and expression. S-shaped poses (page 124) and overpass shots (page 130) work well here.

Tips & Pointers

NOTE
The space is easier to manage and control than with the medium close-up and allows for hair, clothes and accessories to come into play.

COMMENTS
To highlight a character standing in the middle of the frame, the medium long shot is chosen.

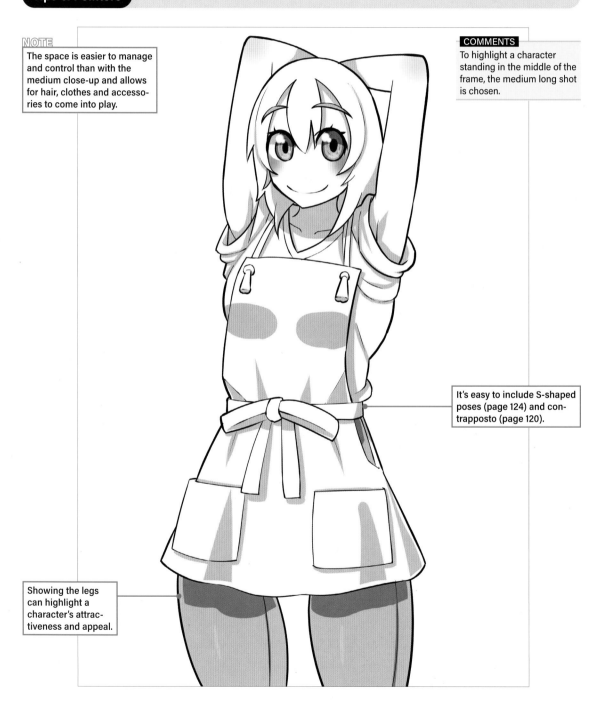

It's easy to include S-shaped poses (page 124) and contrapposto (page 120).

Showing the legs can highlight a character's attractiveness and appeal.

The Basics

Make It Medium-Long

While you give up a bit of immediacy and emotional connection with the wider frame of the three-quarter shot, the enlarged compositional space allows for both motion and emotional expression to co-exist. It's common to draw down to the thigh with the medium long shot, allowing your lithe or long-legged characters to be featured to maximum effect.

The viewer feels less of a connection to the image as the character becomes smaller. As more distance is created between the viewer and the image, the sense of intimacy diminishes. For video games and anime that take into account a sense of distance, the three-quarter shot is often employed when a character is seen leaving, while a medium close-up is often used when they approach.

Beauty Shots

If you prefer slinkier, S-shaped poses, the medium long shot is the perfect pairing. The three-quarter shot is often the go-to approach for model shots or, in the world of manga and anime, stories driven by female characters. But it of course features your male characters just as flatteringly. By raising the position of the waist and elongating the legs, you can aim for a more stylish silhouette than with a medium shot.

Difference between Medium and Medium Long Shots

Figure △ is a medium shot. The curtseying character is in motion, but the image hasn't been framed and presented to the greatest effect.

Figure ○ includes more of the legs to make it a medium long shot. The view of the legs increases the sense of movement. You don't necessarily have to draw the entire figure for the composition. Try changing the impression by expanding the medium long shot and raising the waist.

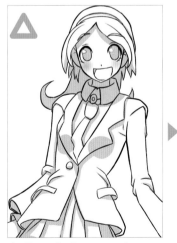

The illustration is strong and complete, but always look for ways to improve it and lift it to the next level.

Stretching the screen a little for the medium long shot, you can see the effects of movement and S-shaped poses. It allows for a wider range of motion than the medium shot.

The medium long shot brings fluidity and flow to your scene, showing the legs or at least allowing the viewer to imagine the rest of the lower body extending beyond the frame.

The empty space can be effectively filled with small items and objects.

Since the legs can be included, the three-quarter shot is perfect for martial arts poses and stances with a focus on the center of gravity.

Raising the character's legs is of course fine. Medium long shots are good at capturing large, expansive movements.

© Tommy Walker Inc. "Silver Rain"

Hair and clothes can flow into the white space for an additional sense of movement.

 # Let's Get Practical

Intimate Expressions

The medium long shot is used to highlight allure and visual appeal. Because it affords you a wider field, more elements can be introduced. There's no rule that says you can't crop out the character's face or a portion of it. Try it depending on time and the demands of the story you're telling.

The face was originally included here in the main illustration. But by excluding the face, trimming it and shifting the focus, the finish was more appealing.

With the face cut off or only hinted at the top of the frame, the shift naturally focuses to the torso and buttocks. When a shift of focus is needed, moving the face out of the frame can be the right move.

 # Take a Look: Practical Applications

Raising the waist and elongating the legs is one way of enhancing a character's attractiveness and appeal.

© Student: RE

The medium long shot allows details, such as the weapons, to enter the frame and an overpass effect (page 130) to be added.

© Tommy Walker Inc. "Silver Rain"

Compositions Featuring the Whole Body
Full-Body Shots

Often used in character designs for games and anime, the full-body shot is relied on for its narrative freedoms, as it focuses, explains or clarifies, moving your story along while maintaining an emotional current and throughline.

Once you've gotten used to drawing only a part of the face or body, you can move on to the entire body, and your range of expression will expand with it.

Tips & Pointers

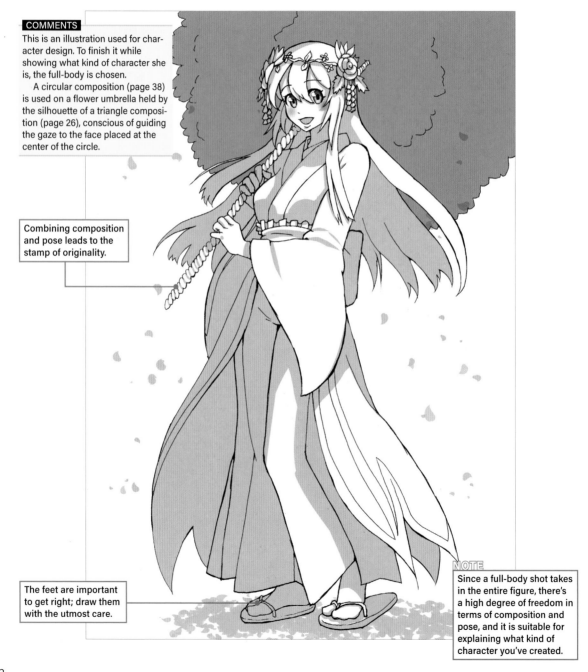

COMMENTS

This is an illustration used for character design. To finish it while showing what kind of character she is, the full-body is chosen.

A circular composition (page 38) is used on a flower umbrella held by the silhouette of a triangle composition (page 26), conscious of guiding the gaze to the face placed at the center of the circle.

Combining composition and pose leads to the stamp of originality.

The feet are important to get right; draw them with the utmost care.

NOTE

Since a full-body shot takes in the entire figure, there's a high degree of freedom in terms of composition and pose, and it is suitable for explaining what kind of character you've created.

The Basics

Singular Visions

Here the whole body is the subject from head to toe. Compared to close-ups and medium long shots (except if it's a low-angle shot or aerial view), this approach lessens the emotional impact, but offers clarity and reveals details about your character other approaches do not.

This compositional approach is great for capturing motion as well as conveying emotion. It also imparts valuable visual information, giving a fully exposed view of your character's defining qualities.

Full-View Pointers

Since the whole body is visible, especially in the case of a landing pose, the lower portion is the most important part. Make sure to draw the character's feet to indicate or suggest the position of the ground.

If you need to, start first with a pencil drawing before you head to the digital space. You can use the box method to get a sense of the three-dimensional character and how she or he occupies it.

Don't forget the feet! This view allows you to focus on usually overlooked areas

Don't Forget the Feet!

Figure ✘ is a full-body illustration, but because of the placement of the feet, it seems that the entire character is floating in the air alone.

In this case, it's possible to make corrections so that the feet are aligned with the plane of the ground. Fix the character's feet firmly. That's all it takes, but it's an important part that greatly affects the finish, look and appeal of the illustration.

As the feet are oddly or vaguely placed, and there's no distinctive sense of the ground suggested, the figure seems off-balance.

By correcting the position of the feet, the sense of imbalance is fixed.

Endless Combinations

Character design is also important, but composition and poses are the lifeblood of a full-body shot, combing a lot of background elements and movement and featuring only one key character. The basic composition here is effective, but if you want to show the character's personality, use alphabetic composition models (page 66) to create an image that's unique.

Or your character can be sitting down, which makes it easier to create a triangle composition. The cigarette smoke guides the gaze up to the face.

The image is also influenced by the depth awareness created by Z compositions (page 70).

The movement was created with inverted triangle composition (page 30) and a distorted Y composition, and the illustration was divided into three parts (page 50). For the contrapposto pose (page 120), overperspective has been added to the weapon (page 130), a powerful shift.

The silhouette of an inverted triangle composition contained within the background of a circle composition.

A Q composition for a figure in a contrapposto pose. The accessories are drawn with an awareness of triangle composition, providing a feel of stability even within a screen alive with movement.

EXPERT TIPS

Extreme Viewpoints

Hyperangle is an unusual vantage point that people usually don't see in daily life, such as the angle of a dynamic flying character viewed from below, or the intense bird's-eye or aerial view of your character seen from directly above.

Here your three-dimensional drawing skills are put to the test; try flipping the illustration horizontally.

In the case of a shooting angle, use the digital camera's timer function, place the camera on the ground if it's a low-angle shot you're after, or at a higher position if taking the aerial view. Or use the selfie stick to actually do it yourself; it's always good to take your own angled pictures for reference.

Low-angle shots of jumping poses are difficult to sketch, but have a powerful impact.

 ## Take a Look: Practical Applications

A "street"-style finish was required here, with the use of overperspective applied to the character's feet.

© Tommy Walker Inc. "Silver Rain"

Triangle composition and Hinomaru composition (page 34) both come into play here. To make the image more interesting, the vertices of the triangle are tilted.

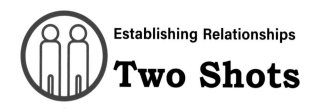

Two Shots

You often find yourself with two characters on the screen, it's the essence of storytelling. Are they friends? enemies? comrades? romantic partners?

Introduce more than two characters and the world of your illustrations will expand, the relationship between your main characters changing depending on the composition. This is an indispensable model for any work that features multiple characters, such as manga.

Tips & Pointers

COMMENTS
To express the relationship and story between the two characters effectively, a two shot is chosen.

Because there are many elements, the composition needs to be carefully planned and laid out.

NOTE
It's fine if one figure is shown in medium close-up and the other is a full-body shot.

By having their poses mirror each other, you can further strengthen the relationship between the characters.

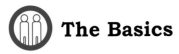

The Basics

Taking Two Shots at It

The two shot is a universal scenario. It's what brings couples to their confessions of love and enemies to their battles. Naturally there's a wide range of applications. You never simply slap down two characters side by side in a meaningless and haphazard way. The two have a relationship, and it's up to you to establish and specify it. If you're drawing more characters than a two shot can accommodate, don't add in the other figures vaguely. Just have a plan in mind and execute it, while being open of course to changes along the way.

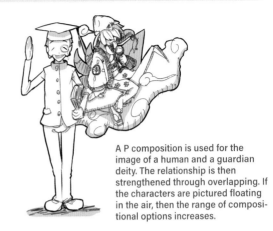

A P composition is used for the image of a human and a guardian deity. The relationship is then strengthened through overlapping. If the characters are pictured floating in the air, then the range of compositional options increases.

Equality and Contrast

When drawing a large number of characters, what to be aware of is whether they're portrayed as equals or rivals. They're treated as equals when you're capturing the relationship between friends and lovers. On the other hand, scenes hinging on conflict, contrast and rivalry can have a strong impact. The charged conflict between the protagonist and antagonist is born, a power imbalance and relationship that will read throughout the screen. These two will never be treated as equals.

In addition to size and gender comparisons, as well as medium long and full body shot comparisons, here I'm also trying to compare the composition of the background character with a frame composition.

Expressing Hostility

Both figures △ and ○ present opponents about to square off. Figure △ is drawn using a strict sense of symmetry, but the hostility doesn't read. Figure ○ brings the two combatants into close proximity. We're now certain they're trying to kill each other.

Symmetry is very effective with a two shot, but overall it's a composition model that needs to be adapted according to the situation.

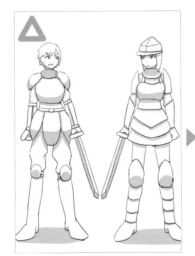

There's no suggestion of animosity here other than the piercing eyes. It's stable due to the symmetry and the elements of M composition, but stability doesn't suit hostile or volatile scenarios.

Although this one exhibits the same symmetry, it makes it easier to see the expressions of hatred they have for each other. Dividing the screen using diagonal line composition (page 42) and crossing the sword to form an X composition suggests the complex relationship and rigid divisions between the characters.

Combining Compositions

Two shots involve twice as much work as a full-body shot, so you need a plan. Consider the other models that might be introduced. Triangle composition (page 26), inverted triangular composition (page 30), circle composition (page 38), diagonal composition (page 42), two-part composition (page 46), symmetry composition and three-part composition (page 50) are easy to use. It's fine even if part of the character is shown in close-up or medium close-up, while a full-body shot captures the entire length of the character on the same screen. For added impact, take full advantage of the contrast.

Symmetry composition is combined with diagonal line composition and X composition, the relationship further strengthened by the entangled arms.

© I Cube Co., Ltd.

A startling image is created by contrasting the medium close-up and the full-body shot as well as the male and female character. Adding to the complexity is the unrealistic angles, where a low-angle view (page 8) and an aerial view (page 12) are used simultaneously.

This image combines diagonal line composition and H composition for symmetry. As there's precision and definition to the landed punch, overperspective is also added (page 130).

In addition to circle composition, the two characters were combined using triangle composition and arranged in a Hinomaru composition style (page 34).

Let's Get Practical

Activities in Common

It's great when you choose the right composition structure or model, put the elements together and use the proper effects on the to unify the image and screen. One trick is to have your characters engaged in the same or related actions. The figure on the right shows the two characters, completely different types, dancing. A slender girl and a stocky well-dressed man inhabit their individual dance styles. The movement, body and gender are contrasted in the composition. By choosing a pose that has an established relationship, you can draw out a more appealing illustration than a simple composition or a single pose.

Take a Look: Practical Applications

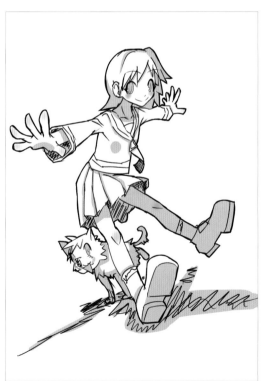

Humans and animals are great combinations for two shots. It's easy to pair them for side-by-side comparisons.

© I Cube Co., Ltd.

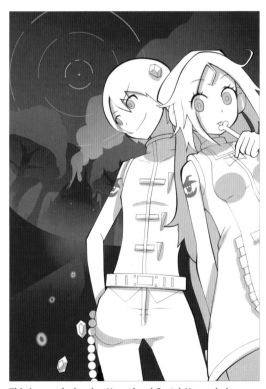

This is a work showing Hansel and Gretel. Use a circle composition for the background. Smoke from a burning house helps guide the gaze, and the relationship is strengthened by using overlap composition (page 78). Two shots tend to be symmetrical, so shifting the character to the right and cropping it makes it more interesting.

Triangular Exchanges
Three Shots

The classic love triangle embodies the love-hate struggles that drive your stories along. Hostility, jealousy, camaraderie can all be captured or suggested by this arrangement. Just be aware of the balance as you add extra characters to the screen. It's important to establish a solid relationship between the three using various composition models of your choosing.

Tips & Pointers

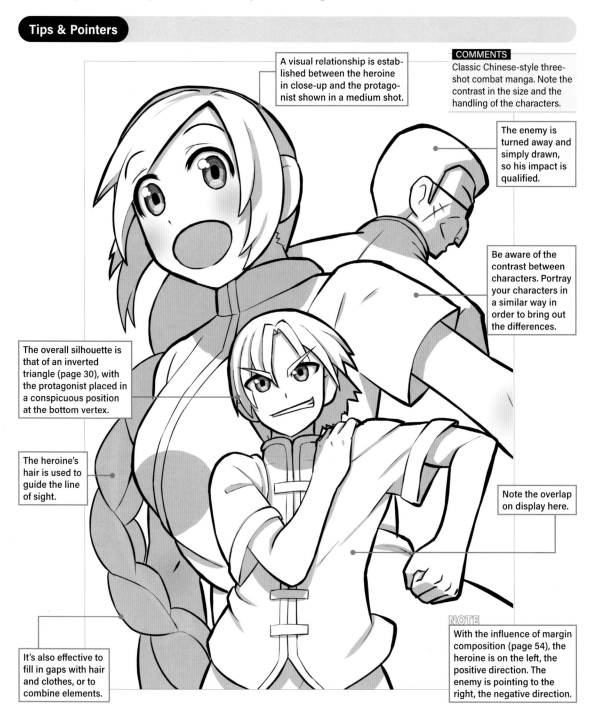

A visual relationship is established between the heroine in close-up and the protagonist shown in a medium shot.

COMMENTS
Classic Chinese-style three-shot combat manga. Note the contrast in the size and the handling of the characters.

The enemy is turned away and simply drawn, so his impact is qualified.

Be aware of the contrast between characters. Portray your characters in a similar way in order to bring out the differences.

The overall silhouette is that of an inverted triangle (page 30), with the protagonist placed in a conspicuous position at the bottom vertex.

The heroine's hair is used to guide the line of sight.

Note the overlap on display here.

It's also effective to fill in gaps with hair and clothes, or to combine elements.

NOTE
With the influence of margin composition (page 54), the heroine is on the left, the positive direction. The enemy is pointing to the right, the negative direction.

The Basics

Rules of Three

While this approach lends itself so successfully to capturing romantic rivalry and conflict, don't forget its other applications such as portraying shifting alliances among allies and enemies. Three figures mean multiple screen elements to explore.

With all three people, there are a lot of screen elements. It's important to make a plan in advance, organize the elements and choose the proper composition and poses.

With three characters, an inverted triangle composition (page 30) can be established just by the placement of the tallest and shortest characters.

Triple Contrasts

With a three shot, the watchword is contrast. Highlight the differences in the sizes of the characters. Be aware of the placement of your protagonist, then add the others into the background, middle or foreground to add depth and layering. In some cases, it's a good idea to split the remaining two people into decorative elements.

It's also effective to differentiate the size of the character, by placing the figure you want to show at a prominent position, or placing the character in a distant, middle or near view to introduce a sense of depth.

Three-character illustrations contain many elements, so it's easier to create a circle composition (page 38).

Triangles: Love and Otherwise

Here there's a triangular relationship between a woman torn between the affections of two men.

Figure ✗ strikes a contrast, with the two love interests facing forward. Are both these men the main characters, and are they both in love with the woman in the background? It isn't clear.

On the other hand, figure ○ in reversing the situation became an illustration more suitable for the story. Even if the composition is the same but it's applied to the wrong scene or layout, the true intention won't be expressed accurately.

Since the two men are rendered large and the woman is facing backward, they're clearly the main characters.

Using the same composition model, now she's the main character, and the two men are relegated to supporting roles.

Three's Company

The three shot is highly compatible with triangle composition and inverted triangular composition. It's also important to divide each character into either close-up, medium close-up, medium shot, medium long shot or full-body shots.

If you really want to draw all the characters the same size, try to put the character you want to stand out in the center. Since there are gaps in the composition, clothing, hair and accessories can be used to fill in.

This is a three-part composition (page 50) with almost no contrast. Complementing the lack of contrast with the power of the close-up (page 86), it finishes attractively even without striking much of a contrast. The challenge is to draw carefully and to reveal character using only a few elements.

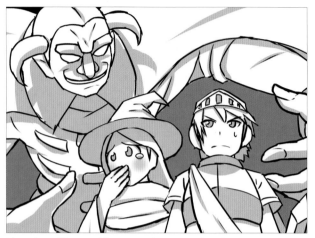

The enlarged image of the enemy character only makes the protagonists stand out in the circle all the more.

If you want to highlight the difference in character size, be aware of the camera position. If you use a low angle (page 8) as shown in this illustration, you can add in medium long shots, medium shots and medium close-ups for a complex and cool touch.

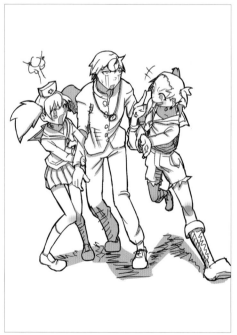

If you can't express a lot of contrast and don't want to employ depth or perspective techniques, draw the characters the same size on the same plane.

 # Let's Get Practical

Wee Folk

Using tiny, shrunken characters in illustrations that have more characters than the three shot or the group shot can accommodate was a popular convention in the 1990s, but it's still found in manga and on novel covers. The advantage of using these disproportionately small characters is that they're easier to place and the screen doesn't become cluttered. The disadvantage is that the tone and mood, under the influence of these reduced characters, becomes comical and lighthearted, so they're typically not suitable to use for serious works.

In the three shot, if the main character is a mascot, it's an interesting choice to enlarge the protagonist, with tiny versions of the supporting characters filling in around.

By directing the gaze of a enlarged character to the next character you want to stand out, you're establishing social hierarchies and power relationships through your illustration.

Take a Look: Practical Application

The main character is large, foregrounded, while the antagonist's power is accentuated through the overperspective on the jutting foot (page 130). The background character helps to complete the frame composition (page 58) with the hair and body used to guide the line of sight.

© Tommy Walker, Inc. "Silver Rain"

Compositions with Multiple Characters
Group Shots

A group shot is a composition that contains many characters on a single screen and thus can accommodate a range of emotions or scenarios. As the number of characters increases, it becomes increasingly difficult to have your illustration come together, cohere. Think of that when you're conceiving of then executing the individual elements. But the effects realized in a powerfully rendered group shot are worth the effort!

Tips & Pointers

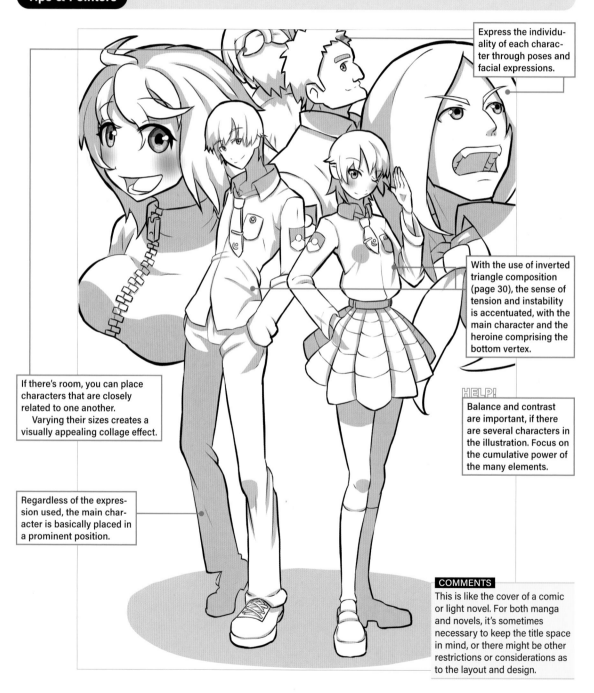

Express the individuality of each character through poses and facial expressions.

With the use of inverted triangle composition (page 30), the sense of tension and instability is accentuated, with the main character and the heroine comprising the bottom vertex.

If there's room, you can place characters that are closely related to one another.
Varying their sizes creates a visually appealing collage effect.

Regardless of the expression used, the main character is basically placed in a prominent position.

HELP!
Balance and contrast are important, if there are several characters in the illustration. Focus on the cumulative power of the many elements.

COMMENTS
This is like the cover of a comic or light novel. For both manga and novels, it's sometimes necessary to keep the title space in mind, or there might be other restrictions or considerations as to the layout and design.

The Basics

Group Thinking

The group shot is a composition that includes four or more characters in the same frame or illustration. It can be used to highlight differences between your characters or just as easily to establish relationships between friends, partners and rivals. With more figures on the screen, the options, choices and freedom increase, but the room for error increases as well. When you start drawing, you need a more detailed plan than with the three shot, such as which composition to use and where to place your main character and supporting roles. The group shot allows your story to advance and your characters' personalities to shine.

Balance and Contrast in the Group Shot

To make your main character stand out, enlarge him, place him in a prominent position or add eye-catching poses and costumes. Or the group shot can be all about harnessing the cumulative power of the group. The figures are treated more equally as the gaze lingers over the many individual elements that make up the whole. It all depends on the type of illustration you want to produce.

Group shots have a unique appeal. With the composed row of faces is a wealth of detail to pore over. The idea is that if there's a lot of visual information onscreen, it lends the drawing a collective power. Also consider using elements of balance or imbalance based on the subject of the illustration and the effect you're going for. With the group shot, just be especially aware of the placement of the protagonist. Consider using the Z composition (page 70) and apply what you've learned so far, such as placing the protagonist in the lower right.

This is a circular composition (page 38) with the protagonist in the center.

Hostility

Figure △ shows a class picture, a photo shoot. Everyone is placed equally, so it's hard to determine who the main character is. Because of the visual monotony, the group competes with the protagonist's presence.

To compensate, move your main character to the center. It's a good idea to place another character you want to stand out next to the protagonist.

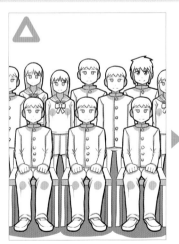

The main character is in the upper right. The rest of the crowd is drawn to make the protagonist stand out, but it's not a successful approach.

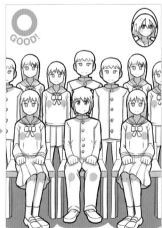

The main character is placed in the middle. The girls are placed at each end to create contrast and to show the ratio between the boys and girls. The girl's legs are directed toward the protagonist to guide the line of sight. A heroine is also placed in the upper right.

Composition Combos

Compositions that are easy to combine with loop shots are triangle compositions (page 26), inverted triangular composition (page 30), circle composition (page 38) and diagonal line composition (page 42).

If you want to distinguis each character individually, use the frame layout (page 62).

It's also a good idea to consider margin composition (page 54) and Z composition when placing characters. If you prioritize your characters and draw with a strong awareness of where and how to place them, your group shot will be even more successful.

This is an example using tiny characters. With so many characters present, a frame is made using the main character's arm, and the miscellaneous characters are grouped in a close-up (page 86). The other important characters you want to show are then drawn throughout the body or placed in prominent positions.

This is a straightforward triangle composition following the standard approach: placing the leading character at the top.

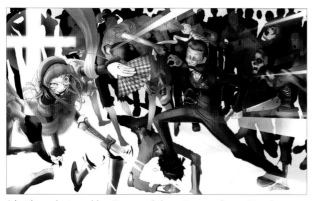

A battle against zombies. Dozens of characters are drawn. Even in games, the bird's-eye/aerial view (page 12) is commonly used, often most effectively if you have a large number of characters. The two protagonists are drawn a little larger with some margins, and the gaze is concentrated with effects.

© Tommy Walker, Inc. "Silver Rain"

Here inverted triangle composition lends a sense of movement and tension, and each character is assigned a different composition. By creating an overlap composition (page 78), it appears that they are fighting together.

© Tommy Walker, Inc. "Silver Rain"

Let's Get Practical

Bringing Out a Character's Individuality

Combining composition models is important in making group shots attractive. However, giving each character a distinctive personality through poses and expressions is just as key in creating a complete, polished work. A contrast of moods and facial expressions—happy, angry or surprised characters—makes the screen come alive.

Don't forget about contrasting poses, dynamic energetic characters interspersed with more subdued ones and large movements countering smaller, more contained gestures. The more you individualize each character, the better your illustration will be.

The protagonist's side (lower right) employs a triangular composition to give a sense of stability and strength. The overall layout is based on the Z composition, with diagonal lines in the margins to express confrontation.

Each character is further finished with a composition that matches the image.

Enemy characters and heroines are often placed in the upper left. The top left is an eye-catching Z composition that captures the enemy side. The main character is often placed in the lower right because a Z composition can easily be tightened and adapted.

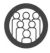

Take a Look: Practical Application

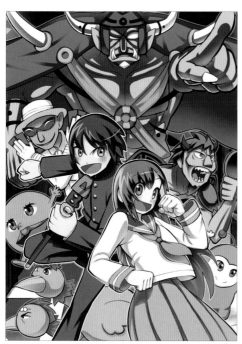

A package-style illustration featuring enemies and allies, it contains a stable and powerful depiction of the main characters arranged in a triangle composition. The varied enemy characters are united in a circle composition, with the enemy bosses in an inverted triangle placed on top of the main characters.

(© Shinkenzemi Junior High School Preparatory Course "Junior High School English ☆ RPG Book" published by Benesse Corporation)

A very simple and straightforward group shot. The heroines are arranged in a circle composition centering on the leading role. The right hand and the Jeep are well-balanced.

© James Togo

Blurred Vision

Have you ever seen blurry backgrounds surrounding the focus in photos and videos?

This blurred effect can easily be used for illustrations. Blurring people other than the main character is a good way of adding depth and dimensionality to the illustration as well as identifying the main and supporting characters. Overlap composition (page 78) is borrowed from the foreground and used to make this main presence stand out.

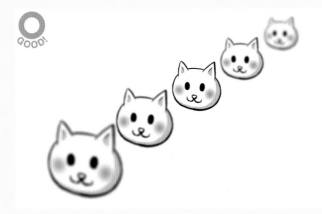

In figure ○, the cat in the middle is in focus. The farther away the detail or element, the stronger the blur.

Figure ✗ is not a successful example. The farthest cat is in focus and the blur is gradually increasing toward the front, but the perspective becomes confused as the effect applied to the second cat is too strong.

By applying and following the rules, your illustrations become more expressive and eye-catching.

Drawing Action Characters

Contrapposto

S Poses

Silhouettes

Center of Gravity

Hair and Clothing

Emotions

Facial Expressions

Action

Special Moves

Invoking Magic

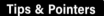 A Pose in Motion

Contrapposto

The sinuously twisting poses you develop not only inject a sense of movement into your illustrations they also feature your characters in complex and compelling poses and positions. Contrapposto posing has influenced art since ancient sculptors started working with the human form. In recent years, it's become a standby in the illustration and animation worlds as well.

Tips & Pointers

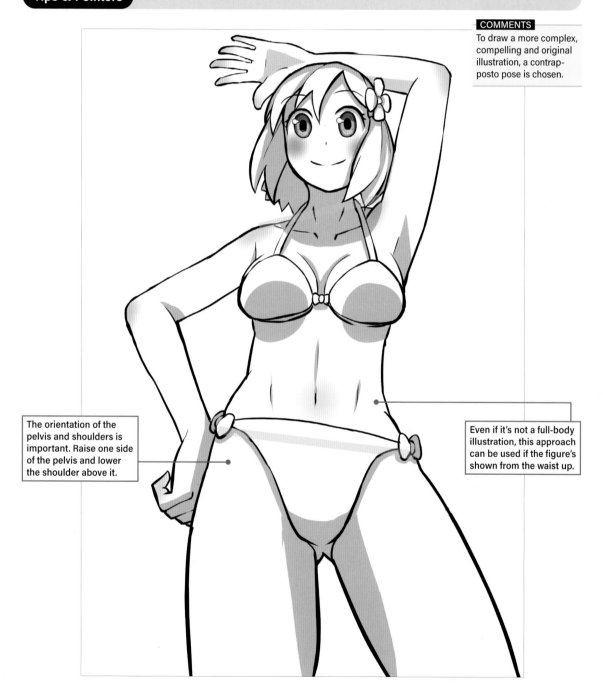

COMMENTS
To draw a more complex, compelling and original illustration, a contrapposto pose is chosen.

The orientation of the pelvis and shoulders is important. Raise one side of the pelvis and lower the shoulder above it.

Even if it's not a full-body illustration, this approach can be used if the figure's shown from the waist up.

Strike a Pose

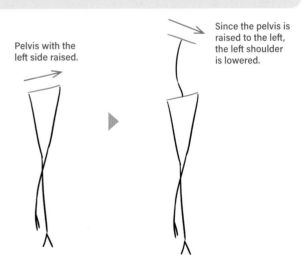

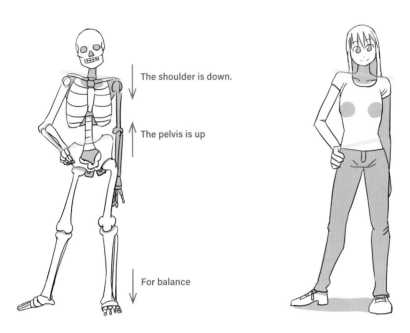

Contrapposto Basics

Contrapposto is a pose where the pelvis and shoulders are inclined in opposite or opposing directions. If the center of gravity is applied to only one leg, the other leg will be shifted to the side, so the pelvis on the side where the center of gravity is applied will rise. The upper body tries to counterbalance, and the shoulder on the center-of-gravity side hangs down as a result. As a result, the pelvis and shoulders become asymmetrical, and the pose suggests motion and flow.

The shoulder is down.

The pelvis is up

For balance

A Twist of the Hips

One important factor with contrapposto is to know which direction the pelvis or shoulders are tilted: up or down.

First determine the direction of the pelvis and decide whether you're going to the left or right with the line. Next, draw another line for both shoulders that's inclined in the opposite direction as the pelvic line. It's easier to add in the spine at this stage.

Pelvis with the left side raised.

Since the pelvis is raised to the left, the left shoulder is lowered.

121

Box Sketching Improves the Image

Once the pelvis and shoulder lines are determined, draw the shape in a box if necessary. If you have a sense of what you're going for, a posed body in mind, you can start drawing at this point. Finally, like a mad scientist, it's time to add the flesh. A natural walking pose is now possible.

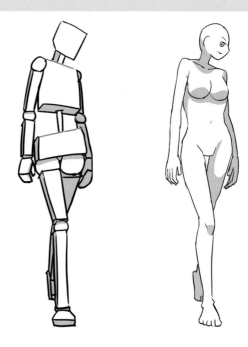

Contrapposto Dos and Don'ts

Figure △ shows an example where no contrapposto posing is applied. A rigid, stiff-limbed figure results. Figure ○ shows the contrapposto version, raising the left pelvis and lowering the left shoulder. A more natural stance and motion result and the appeal of the pose increases. Contrapposto poses can be challenging until you master them. Remember that the pelvis and shoulders tilt in opposite directions.

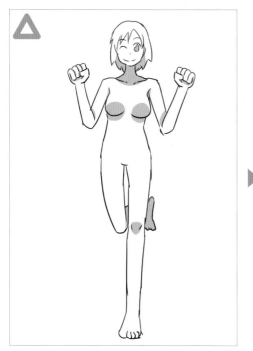

The overall result seems to be O.K., but the movement is stiff, as a contrapposto pose hasn't been used here.

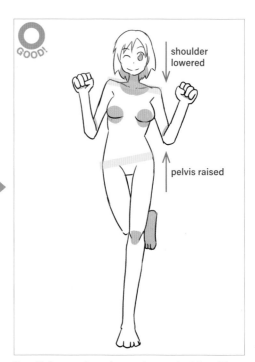

Now it's been redrawn in a contrapposto style, with an awareness of the slant in the shoulders and pelvis. It's a more dynamic and attractive pose as a result.

122

A Range of Poses

Beyond Standing

Contrapposto can be applied to any pose, whether sitting, sleeping ❶ or flying ❷ to bring your characters to life.

Contrapposto applied to a sleeping form. Here the body line can be emphasized, so it's perfect for forms flattered by an S-shaped pose.

A jumping pose. There are several ways of conjuring action (page 154), contrapposto being just one of them. You can emphasize the feeling of dynamism by increasing the torque in the body.

Take a Look: Practical Applications

Contrapposto can be used even in medium long shots.

© Student: RE

A strong example of the use of contrapposto. Shift your character's posture diagonally to make it look like this.

Capturing the Curves
S Poses

Used to capture softness or to express traditional notions of beauty, the S-shaped pose is the perfect choice. The shape suggests dynamism and flow and is often used for the natural sense of depth and flow it brings to an illustration.

Tips & Pointers

There's no need to stick strictly to the S shape, just be aware of the curves.

COMMENTS
In order to capture a curvaceous character's shape, an S-shaped pose is chosen.

S-shaped poses can be created even with disjointed or scattered elements.

Emphasize the S shape by increasingly twisting or bending the body.

There may be multiple S-shaped characters on the screen. It's also a good move to color the screen by combining multiple characters who are similarly posed.

The S-shaped pose can also be used for backgrounds and motifs.

The Basics

Gimme an S!

Even though it's called the S-shaped pose, the pose and the figure don't necessarily have to conform explicitly to that letter's shape. As long as it has an impressively sinuous curve, the twist of the body can assume any form. Because it's ideal for expressing beauty and and conveying an angular sense of softness, the pose is often used for stereotypical model, glamour or beauty shots.

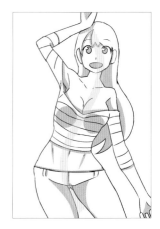

Enhancing the Image

There are many things that enhance S-shaped characters. Hair can be easily added in curved and flowing ringlets and locks. The same goes for flowing accessories such as scarves.

You can also have the character interact with the background in some way or adjust the balance by connecting the figure to elements in the landscape or setting.

If the pose isn't quite right, you can make adjustments by balancing the hands and body in the background.

Boldly Posed

Figure △ is an attempt at a "glamour shot," but the curve is weak. The body needs more bend and twist to it. The key parts to connect are the head, the waist that forms the S shape and the closing legs. Use the breasts and hips as the basis for creating curves.

The chest and hips form slight curves here, but the shape and outline of the S are weakly.

By twisting the hips and bending the legs, the S-shaped form is more expansive and flowing. By enlarging the key points, a more appealing form results.

ⓢ Alphabet Poses

Look Them in the Eyes

The S-shaped pose is also helpful in determining the background composition, as it brings a strong sense of depth and motion to the screen. So when working with S-shaped compositions, it's important to choose the correct eye-level height.

For example, by showing the road from above ❶, or compressing the depth of the curve of the S by lowering the eye level ❷, the effect will be flatter and less dimensional. Express a natural sense of depth by placing the eye level ❸ at the right height.

An S-shaped road seen from directly above. It's a flat, too-high view that doesn't offer any feel for or sense of depth.

Now it's seen from a vantage point that's too low. The space is too compressed, so there's little sense of depth created.

Here it's seen from the appropriate vantage point. The depth can be felt.

Along the Dotted S

As with diagonal line composition (page 42), the line or shape of the S curve doesn't have to be continuous in your drawing, just as long as the suggestion of continuous flow is created. Even if comprised of scattered or discontinuous elements, adding an S shape results in a stable and balanced screen, as does the use of Z composition (page 70). Arranging things in alphabetic form, and not just S-shaped poses or Z compositions, makes the overall illustration easier to stabilize.

Combining Lines

An attractive screen can be created with just an S-shaped pose, but if you want to advance the illustration, several other lines can be incorporated. Curves, circles and straight lines are just some of the options. If you put another curved shape on the screen, a softer overall impression typically results.

A straight line enhances the softness of an S shape and adds tension to the screen, compared to an illustration with only a single S. However, if the straight lines aren't used well, they'll weaken the way your main character is seen and perceived. Try adjusting the lines, as described in the section on diagonal line composition.

The straight line has the effect of enhancing the softness of the S shape and giving the screen a sense of tension compared to just an S shape appearing alone.

Ⓢ Take a Look: Practical Applications

S-shaped poses are often used in conjunction with contrapposto (page 120).

You can introduce more than one S shape. The curves of the plants and planets at the edges of the screen create a softer impression.

© Adrenalize Co., Ltd. "Investigator Run Run"/Seijiya Fujiwara

127

The Body's Range of Motion

Human limbs, appendages and joints such as the neck, fingers and hips move fairly flexibly, but there's a limit to their range of motion. Drawing a figure stretched beyond this range will give your illustration a sense of incongruity. Knowing the limit and range of motion is important when deciding on a pose.

● **Arms and Legs (Front)**

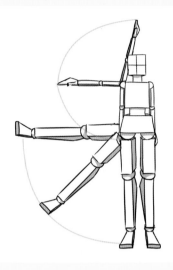

● **Arms and Legs (Side)**

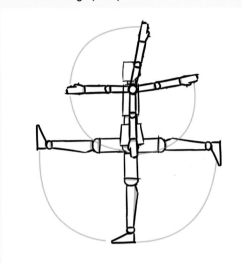

Upper Body

● **Elbows**

They can only bend in one direction that advances them straight forward. Although they appear to swing from side to side, the motion is actually caused by the shoulders.

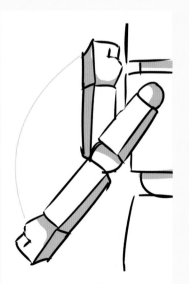

● **Head**

Can be moved front to back or left to right.

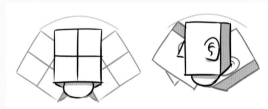

● **Shoulders**

They carry a wide range of motion.
They can be rotated, reaching all the way around, except for some areas of the back.

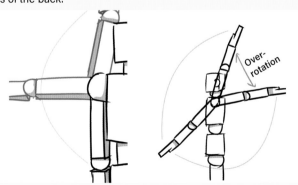

Over-rotation

● Wrists

They move within a limited range: front to back and left to right. There are many small bones at the base of the wrist, so the range of motion is surprisingly narrow.

● Fingertips

The fingers on both hands can be moved from a straight position to the full frontal range of bending as well as slightly to the left and right. Although they can be bent slightly backward, they can't be stretched too far because of the rigid finger bones.

四本指　　親指

Lower Body

● Waist

A person can bend over until the chest touches the legs. There's a limited range of left-to-right motion, so cast your characters in poses that don't exceed this range normal people, not acrobats.

● Hip (Thighbones)

Parts located below the waist can be moved back and forth and left and right. The hip are essential for motions such as frontal kicks.

● Knees

Like the elbow, the knees extend in one direction from extended straight to swinging backward.

● Ankles

Can be flexed or rotated up and down. Although they can be moved slightly to the left and right, ankles are also similar to wrists with many small bones, so the range of motion is limited.

Exaggerate the Powerful
Overperspective

Overperspective is a technique that exaggerates a part of the body or portion of an object to express power and momentum. It's also useful to create an even greater sense of depth on the screen. It's a staple of action manga, mostly found in works targeting or featuring boys.

Tips & Pointers

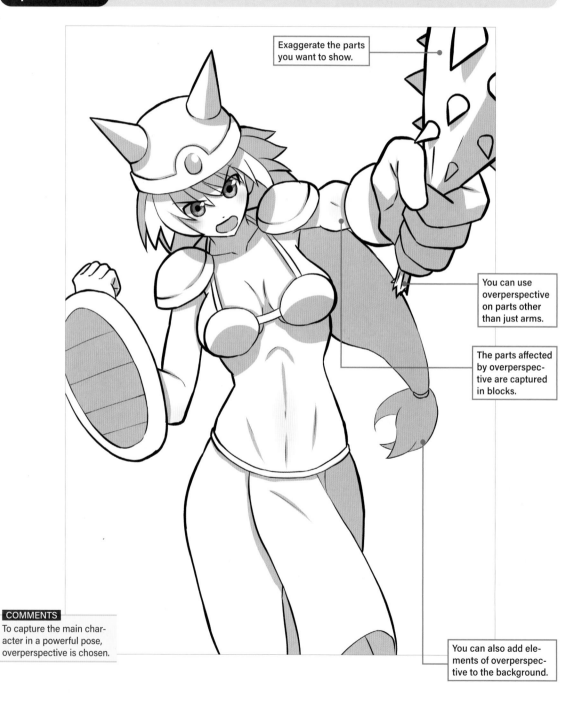

Exaggerate the parts you want to show.

You can use overperspective on parts other than just arms.

The parts affected by overperspective are captured in blocks.

You can also add elements of overperspective to the background.

COMMENTS

To capture the main character in a powerful pose, overperspective is chosen.

The Basics

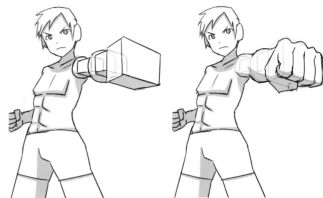

A Long Look at Overperspective

A pose that places an exaggerated focus on a specific part or element, overperspective conveniently ignores and distorts reality. By typically coming directly at the viewer, it brings depth, power, force and motion to your illustrations.

If you want to draw a protruding fist, the box or block method allows you to manage the recessed perspective. The strength of the perspective changes through the fist, forearm and upper arm, much less the joints. Knowledge of the muscles is also important for supplementing details. The muscles are explained in the appendix (page 166).

Digital Details

Drawing using overperspective can be difficult because it depends on your eye and own sense of balance. In digital illustration, it's useful to use the Cut and Enlarge/Reduce functions to adjust the exaggerated part many times to find a size that's right. However, the difference in line thickness and image quality may be noticeable, so this method is not suitable for pen drawings.

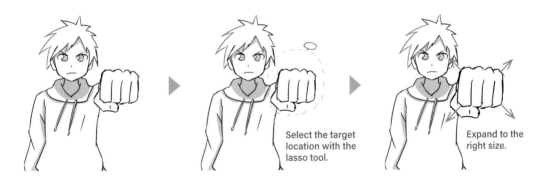

Select the target location with the lasso tool.

Expand to the right size.

EXPERT TIPS

Enlarged Parts
CLIP STUDIO PAINT has a 3D drawing doll with a "manga perspective function" that enlarges part of the body. You may use this as a guide in some cases. However, if you rely on these functions too much, your work will become stiff, so use it only as a guideline and ultimately draw on your own.

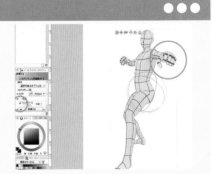

Overperspective Dos and Don'ts

The ✖ figure represents a failed attempt at overperspective. The image seems incomplete and shows a lack of experience drawing the body.

The character in ◯ is drawn with an awareness of the body and joints, so a more natural sense of overperspective is achieved.

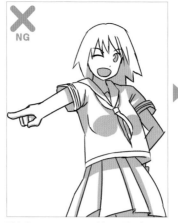

This is a common problem. The image is scattered, unfocused, incomplete.

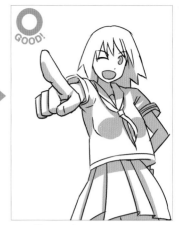

Overall corrections were made to intensify the sense of overperspective. The effect is difficult, but the results are worth the effort.

 # Power of the Pose

Overperspective Beyond the Arms

Overperspective most often involves the arms and hands, but it's equally as powerful when applied to legs and weapons. It's important to understand the structure when compressing or expanding the sense of distance, and then reducing and modifying the imbalance and incongruity the effect introduces.

If you have a sample such as a drawing doll or a model gun, observe it carefully. When viewed close up, it's easier to grasp the shape and perspective.

The character and pose form a triangle composition (page 26), with the added intensity of overperspective.

The sense of depth and force will be exaggerated if part of the area where overperspective is applied is cropped off.

Overperspective in the Background

It's rare to use overperspective only in the background, but often the overperspective that enlarges the object in front is connected with the effect that makes the object in the back smaller.

 It's mainly used when contrasting or emphasizing the overperspective in the front or to show something approaching from the back. The trick here is to capture the body and joints in blocks. When putting the two layers of overperspective onscreen at the same time, the front side is drawn larger and the back side smaller. There are a lot of different ways to approach it and applications to use. Choose the method that makes it easiest for you.

Use hair to fill the frame

Trajectory of the tilted head

Take a Look: Practical Applications

A dynamic use of overperspective involving the whole body.
© Student: RE

Overperspective is also suitable for chibi-style illustrations.
© Tommy Walker Inc. "Silver Rain"

Silhouettes

If you're looking for a unique pose or want your character to make a memorable impression, consider the silhouette. It's most effective with the full-body renderings seen in character design. A game's characters are designed so that they can be recognized easily just from their silhouettes.

Tips & Pointers

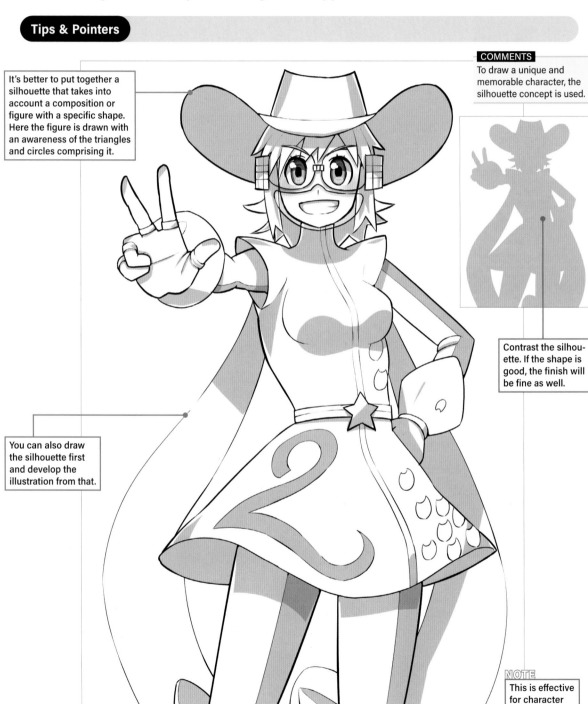

It's better to put together a silhouette that takes into account a composition or figure with a specific shape. Here the figure is drawn with an awareness of the triangles and circles comprising it.

COMMENTS
To draw a unique and memorable character, the silhouette concept is used.

You can also draw the silhouette first and develop the illustration from that.

Contrast the silhouette. If the shape is good, the finish will be fine as well.

NOTE
This is effective for character design too.

The Basics

Seen in Silhouette

With silhouettes, characters' distinguishing features and defining characteristics—faces, facial expressions, hair, clothes—are set aside as the figures are reduced to simple shapes, shadows of themselves. Freeing your characters of distinguishing details allows you to focus all the more on their poses and presence. In the game industry, where character design and poses go hand in hand, silhouettes play an important role.

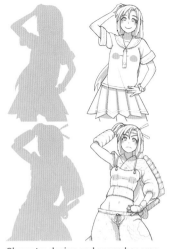

Character design and poses become more powerful and compelling when you're conscious of silhouettes.

Power of the Pose

Silhouette Secrets

Pay attention first to the outline of the silhouette and don't be distracted by the internal detail until the finish.

First, draw the body of the character. At this point, be aware of the silhouette ❶. Consider the composition of concrete shapes such as triangles, circles, alphabetic and other shapes, and form a unified, defined silhouette.

Next, think about hair and clothes that will really stand out ❷.

Paint in black, look at the shape of the silhouette ❸ and adjust the overall balance. If you think you've got it right, you can complete it with a clean copy ❹.

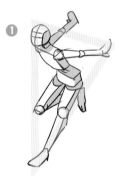

❶ A moving silhouette within an inverted triangle. The head and left hand became an inverted triangle, but it seems more interesting as a silhouette to extend both arms back and make it into a Y.

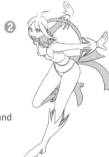

❷ A bird-inspired silhouette, both arms are performing the same movement, and the decoration is also symmetrical. A waistband is added and the ponytail completes the circular composition.

❸ Once painted and silhouetted, consider whether there's any extra space for additional elements. Here there's too much space in the ponytail and a slightly larger circle can still be made with the cloth on the waist.

❹ A round element is needed to contrast the silhouette. Finally, the work is finished by having the space filled with feathers.

Posing and Composing with Silhouettes

There's a way to make your work more unique by using silhouettes.

First, draw a solid silhouette ❶. You can draw with the shape in mind or sketch at random. It's not about drawing the perfect silhouette, but by drawing it to look like a basic figure to some extent, it will be easy to finish.

If you can draw an interesting and eye-catching silhouette, you can draw a character to match ❷. Determine the direction of the character while arranging the lines ❸. Prepare and finish ❹. You never know what you'll produce, so be prepared for some unexpected results!

❶ Here, triangles and inverted triangles are included.
Draw an erratically shaped or unusual silhouette that captures your imagination.

❷ Reduce the transparency of the silhouette and draw the character along the shape. Follow the silhouette as closely as possible.

❸

Prepare the rough sketch. If you can't come up with a shape that fits the silhouette, or if you have better ideas, you can alter the plan. The lower flowing garment looked like a skirt, so a young woman fits best. At this point, it looked like a barbarian, so it's best to give her a wild look.

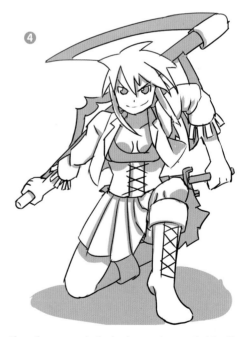

❹

Since the weapon in the background suggested the film "*Ikari*," the outfit is finished to look like a female pirate. At this point, parts that are not needed or consistent can be removed from the silhouette.

EXPERT TIPS

Dark Shadows

With digital and graphic design, silhouettes are used for the process of separating or masking a portion of an image (such as the background) so that it doesn't show. Traditionally silhouettes have been used in advertising, particularly in poster design, because they can be cheaply reproduced while still centering on striking eye-catching imagery. With digital processing, the contrast can be enhanced through the manipulation of the contrast curve on the image. To borrow from photographic techniques, the background light might be natural (such as a cloudy or open sky), misty or foggy (or at sunset), seen through an open doorway (a technique known as contre-jour) or subjected to low-light studio techniques.

 # Examples

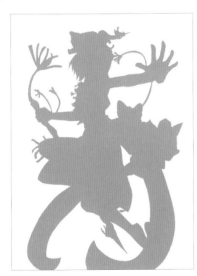

A silhouette with extra consideration given to the pose and the modeling of the character. It's an image of a Japanese-style magical dancing girl.

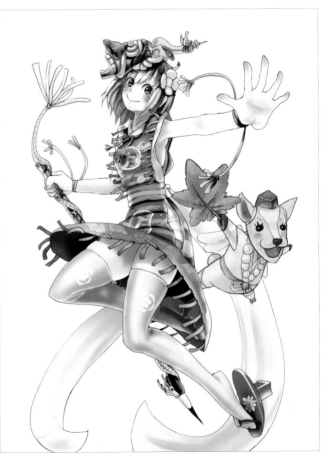

Balance and Center of Gravity

The center of gravity is an important factor when posing, and properly locating it in the illustration makes it easier for you to achieve a sense of balance and stability. It's an element that's necessary for almost all illustrations, but it's particularly effective when drawing a full-body pose.

Tips & Pointers

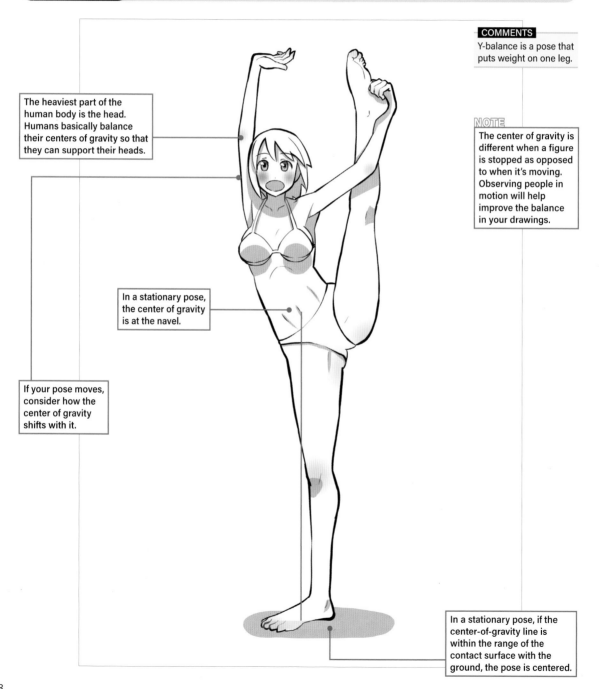

COMMENTS
Y-balance is a pose that puts weight on one leg.

The heaviest part of the human body is the head. Humans basically balance their centers of gravity so that they can support their heads.

NOTE
The center of gravity is different when a figure is stopped as opposed to when it's moving. Observing people in motion will help improve the balance in your drawings.

In a stationary pose, the center of gravity is at the navel.

If your pose moves, consider how the center of gravity shifts with it.

In a stationary pose, if the center-of-gravity line is within the range of the contact surface with the ground, the pose is centered.

⬇ The Basics

The Body's Fulcrum

Think of the human body as basically balancing the center of gravity to support the head. However, it's the feet on the ground that ultimately support the body. If the character appears to be floating in the air, even if perfectly balanced, the viewer will not see the illustration as having a center of gravity. Pay attention to eye level and the location of the ground.

Remember: When a figure is standing normally, the center of gravity is at or just below the navel.

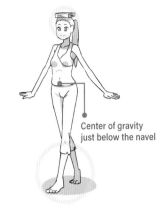

Center of gravity just below the navel

A model walking with a book on her head makes it easy to locate the center of gravity beneath the navel.

Deliberately Off-Balance

Drawing in the center-of-gravity line brings balance and stability to your scenes. When standing normally, the center of gravity extends downward between and beneath the feet. If the range of foot contact is reduced, such as when standing on tippy toes, the range of balance of the center of gravity is naturally narrowed, bringing a sense of tension to the screen.

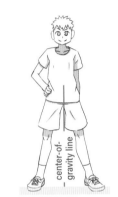

center-of-gravity line

The wider the range of the ground beneath the character, the greater the sense of stability. This is the same principle as triangle composition (page 26).

Both Feet on the Ground

Consider a slanted illustration. Because the figure △ was drawn without an awareness of the center of gravity, the character will likely fall over. By spreading the legs wider apart so that the center of gravity line is within their range, the illustration has a balanced center of gravity. The man's on solid footing.

The center of gravity is particularly noticeable when there's a foot on the ground. Be aware of the placement of the center of gravity unless you intentionally want to disrupt it.

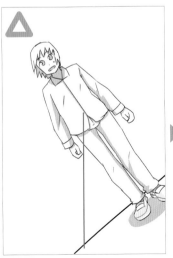

The center-of-gravity line is located far from the feet here, so the character is likely to topple over.

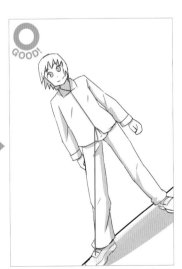

By extending one leg and creating more stable footing, the center of gravity is now within the spread of the legs. The figure is properly balanced.

Action's Center of Gravity

When a character moves, the center of gravity moves with her. As a guideline, it's often easier to think of the entire pose as an inverted triangle with the lower vertex as the center of gravity.

To improve the balance of the center of gravity of a moving character, it's a good idea to incorporate a pose that allows you to imagine the character's next movement. The next step or connecting action that follows predicts or sets up the upcoming shift in the center of gravity.

For example, if the character is running, the back leg is the next to move forward ❶. It's important to draw that leg properly. In addition, if the illustration includes a fist/hand in the foreground, the action will be more complete and a better sense of balance established ❷ as the center of gravity that shifts along with the movement of the opposite hand.

By pulling backward, it has the effect of putting the weight of the upper body on the protruding fist. This illustration displays a strong sense of and the location and fluidity of the center of gravity.

EXPERT TIPS ● ● ●

Check Your Balance

Through the years, I've drawn countless pictures focusing on character movement. To be honest, I used to have a hard time producing illustrations that captured or conveyed motion.

This is me, but when drawing action illustrations, when I approach the center of gravity, I don't think about anything. I draw using my senses. Of course, it took me a while to acquire and refine my approach.

I learned about the center of gravity by copying the photos of athletes, including marathon runners, and watching movies carefully. Eventually I was able to draw the balance of the center of gravity even in poses I'd never worked with before.

If you can, take a look at reference photos of bodies in motion. However, in the case of hyperangles and fantasy poses, it's often impossible to rely on reference materials. It's important ultimately to rely on your own developing sense of balance.

Utilizing the Pose

Stick to the Basics

There are characters that sport heavy and unwieldy swords and guns, weapons that require superhuman strength. Luckily illustrations can depart from reality and support such flights of fancy. In the realm of fantasy, it's fine if a diminutive character is carrying a heavy weapon. It can be a striking and memorable pairing because of the blatent contrast. In order to accurately capture the balance of the center of gravity, draw the character's pose when holding a heavy object.

For example, as shown in the figure on the right, when carrying a heavy object on their backs, people lean forward to balance. In fictional scenes, it's equally as important to have a basic pose in order to be persuasive.

And as always, be aware of where you've placed the center of gravity.

leaning forward

Take a Look: Practical Applications

One hand is prepared to support the enormous sword in the pose. In addition, a long ponytail is added to the white space on the right part, and as a result, the triangle composition (page 26) becomes larger and more stable.

© Student: RE

An illustration that has its center of gravity on the hammer.

© Tommy Walker Inc. "Silver Rain"

Movement Beyond the Body

Hair and Clothes

Hair and clothes are also important components for determining the character's pose and the compositional style used to enhance it. They suggest and express motion in addition to bringing essential details and balance.

In order to create attractive pictures not only for illustrations but also for advertisements and magazine shoots, many techniques are used to make hair and clothes flutter. The dynamic movement of hair and clothes is particularly suitable for chibi-style illustrations.

Tips & Pointers

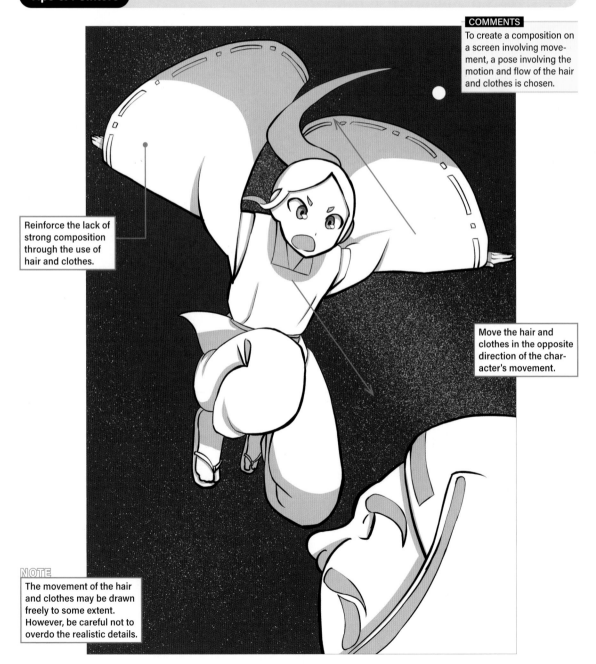

COMMENTS
To create a composition on a screen involving movement, a pose involving the motion and flow of the hair and clothes is chosen.

Reinforce the lack of strong composition through the use of hair and clothes.

Move the hair and clothes in the opposite direction of the character's movement.

NOTE
The movement of the hair and clothes may be drawn freely to some extent. However, be careful not to overdo the realistic details.

142

The Basics

Help from Hair and Accessories

Clothes and hair are important parts of an illustration that influence the final pose and overall composition. Hair and light garments can easily change shape, fluttering and flowing as characters move.

Also, unless the character is bald or naked, hair and clothing are essential, inescapable elements present in almost every illustration. They're an essential element for action poses for the flux and aerodynamic detail they bring.

Characters with long hair or wearing long, fluttering garments are the ideal candidates. For characters with other styles, look for a composition or pose that doesn't rely on hair or clothes.

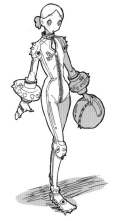

It's not suitable if the character's hair is short or if the clothes are tight.

Opposite Motion

If you want to express the character's movement through hair or clothing, there's a general rule: shift the body in the opposite direction.

Neither hair nor clothes move on their own. It's the movement of the character that sets them in motion, or the air or environment around them. It depends on the details of your story and scene, but they should be oriented in the opposite direction of the movement.

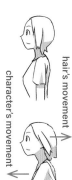

The scene is stable. Both the hair and clothes are not moving now.

Walking in a quicker pace than the previous image. Since the character moves forward, the hair flows backward. The arms move forward, so the sleeves of the clothes are also moved back.

The Flutter of Sleeves

Shirt sleeves are the part perhaps most affected by a character's movement, and it's often the most noticeable. Since sleeve are basically lighter than other clothing items or parts of the garment, it's easy to set them in motion.

Draw the movement of the sleeves with an awareness of solids. Many people draw flat sleeves, but if you imagine a box and draw it three-dimensionally, the result will be more convincing. If the sleeves are made of heavy material, they can be shaped like a box. But if they're made of light material, they'll look as if they're squeezed in the opposite direction.

An image of a square or trapezoid box (the sleeve) with a round and thick bar-like shape (the arm).

Since the sleeve pulled forward, wrinkles are added from the direction where the force is applied. For thick fabrics, leave some roundness at the back.

Because it's a thin fabric, bind it at the back, then add in the folds and contours.

Making Mistakes with Direction

Figure ✖ shows a character moving from right to left, but since the hair and sleeves are moving in the same direction as the character, the motion from right to left appears to be obstructed. So here the direction of the hair and clothes was altered to shape the movement from right to left on the entire screen.

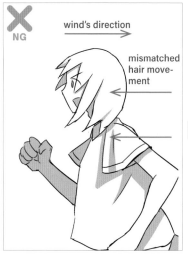

It looks like a strong wind is blowing from behind.

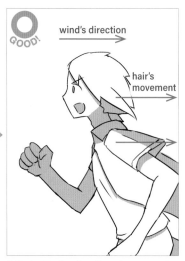

Adjusted to the direction of movement, the suggestion of motion from right to left has increased.

Power of the Pose

Compositions Involving Hair and Clothes

Hair and clothes as a key design element for composition, great for filling blank or white space as well as adding embellishment and decoration.

Although it's hard to compose a character using inverted triangle composition (page 30) paired with either a full-body illustration or a medium close-up, you can create an inverted triangle composition by having long hair or a scarf flutter in the wind. So even a composition that's usually difficult to compose can be shaped naturally by using hair and clothes.

An image of a woman fishing in a boat. It's difficult to create an inverted triangle composition with so little movement.

Lying down allows for more possibilities in terms of hair and clothes. This illustration forms a circle composition (page 38), a T composition (page 66), as well as an inverted triangle composition (page 30).

Multiple Characters

As was discussed with the handling of group shots (page 114), hair and clothes are an effective tool to fill in your screen much less to distinguish your individual characters. Filling in with flowing locks or fluttery garments results in a more unified and dynamic illustration. Although hair and clothes don't move all that much in reality, they can flow freely in the world of illustrations, so harness that freedom and power in your work. Remember not to overdo it; you can always slightly reduce the movement of hair and clothes if it seems too much.

Show restraint when drawing dynamic or sweeping movements. If you're going for realistic motions and gestures, you can reduce the movement of the hair and clothes a little or change the compositional model.

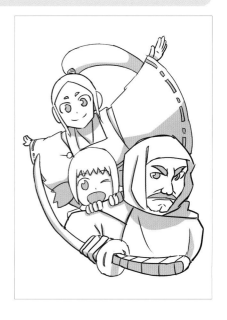

 # Take a Look: Practical Application

In order to complete the heroic pose, the cloak dynamically forms an inverted triangle.

© Toolmart

A Feel for Feelings
Emotions

Not just facial expressions, but poses also show emotion. The more emotionally expressive your characters are, the more believable, the more "human" they seem. A pose that conveys emotion is especially important in manga and anime. Many illustrations, such as the medium close-ups used in games, rely almost exclusively on facial expression as the way of showing emotion. But often that's too restrictive and can't be relied on alone. The right pose expands your character's range of emotional expression.

Tips & Pointers

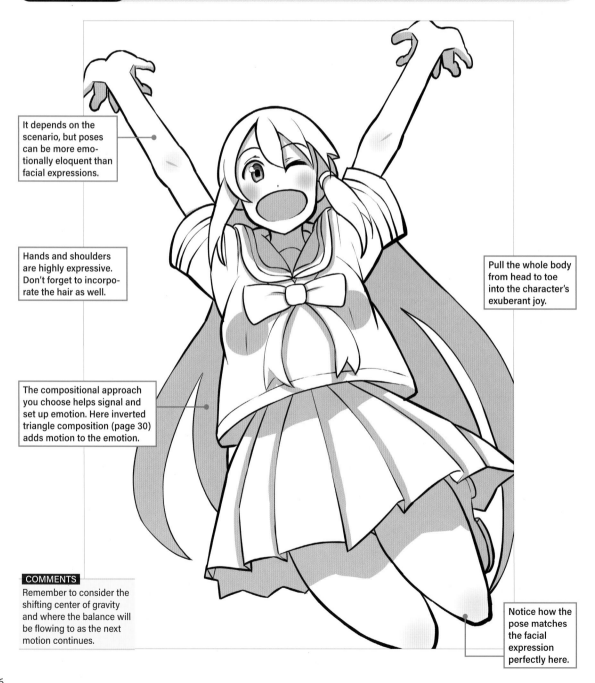

It depends on the scenario, but poses can be more emotionally eloquent than facial expressions.

Hands and shoulders are highly expressive. Don't forget to incorporate the hair as well.

The compositional approach you choose helps signal and set up emotion. Here inverted triangle composition (page 30) adds motion to the emotion.

Pull the whole body from head to toe into the character's exuberant joy.

COMMENTS
Remember to consider the shifting center of gravity and where the balance will be flowing to as the next motion continues.

Notice how the pose matches the facial expression perfectly here.

The Basics

Emotional Import

Basic poses convey the four key moods or emotional modes: joyful, angry, sad and humorous. While facial expressions (page 150) go a long way in carrying a scene's emotional import, the pose reinforces the mood you're creating.

By combining motion and emotion, your characters will seem more lifelike, more real. On the other hand, if it's a basic type you're going for, such as the ruthless, heartless villain, sometimes using just facial expression is enough.

Use the entire body and the compositional mode, according to the situation, to suggest and convey the emotion. In other words, bring the entire screen into play.

Having the hair stand on end is a great way of showing anger.

Shoulders, Hands and Hair

Other than the face, the most important emotional registers (or expressive parts) are located in the shoulders and the hands. Especially with a medium close-up (page 90), they're eloquent inclusions to support and convey the mood you're going for. And don't forget about your character's hair. Just don't spend too much time trying to make it look realistic, there's no need.

Here are the four basic emotional registers, and how they read in the body:

● **Joyful**
Shoulders: Raised up
Hands: Raised up, though in some situations fists are appropriate
Hair: Tousled, unkempt

● **Angry**
Shoulders: Lifted to the extreme
Hands: Clenched into fists, mostly raised or prepared to punch
Hair: Looking as if it's pointed upside down

● **Sad**
Shoulders: Hung down
Hands: Held loosely, or clenched into fists in cases of extreme anguish
Hair: Sweeping downward preferably

● **Humorous**
Shoulders: They may be raised or bit, or relaxed and slightly slumped
Hands: Barely clasping
Hair: Reflects the relaxed, neutral pose

Full-Bodied Emotions

Emotions can be read in the whole body—not just the face, shoulders and hands of course—so use the entire figure. Extreme emotions like anger and elation are felt throughout, accompanied by shaking, twisting or flying through the air. See the discussion of action (page 154) and hair and clothes (page 152) and try and integrate those aspects into your work as well.

1 One or both arms can be lifted, the body bent or twisted in its expression of elation. Jumping for joy is also an option, especially for a title illustration. Compose then crop the screen, not leaving too much margin.

Also, composition and trimming that use the screen dynamically without creating too much blank space deliver a stronger impact.

The sense of anger is enhanced through overperspective (page 130) on the fist, a low-angle view (page 8) and a hint of stress and instability introduced through the use of diagonal line composition (page 42).

To capture sadness, it's O.K. to cover the face with the hands or twist and contort the body to physicalize the emotional pain. An aerial/bird's-eye view (page 12) or margin composition (page 54) works, though an inverted triangle would be a strong option here as well.

A more relaxed, casual version of joy. A circle composition (page 38), ideal for expressing gentleness, works well here.

Matching Pose and Expression

The example is a simple attempt at conveying happiness that's gone awry, veering into anger or mental instability. The failure here can be traced to the fact that the pose and expression are a mismatch. With the other example, the viewer doesn't struggle to accurately read the happiness on her face. Human emotions are complex. Often you have to combine different poses and expressions until you get it just right.

If you want to draw expressions that aren't confined to simple emotions, combine different emotional poses and expressions until you find the right effect.

The facial expression and pose don't match. If it's insanity you're after then leave it as is, but as an attempt at joy, it's a miss unfortunately.

The facial expression and pose are working together here, so the strong sense of happiness comes through.

Take a Look: Practical Application

Lifted shoulder, arms crossed, hair on end: The entire body is pulled into this portrait of anger.

© Student: RE

The Big Reveal

Facial Expressions

The face is the main place when you want to show and locate emotion. Facial expressions not only reveal character, they make your fictional creation appealing, relatable and "real." In anime and manga, a character's expression changes rapidly, but at the same time, this emotional transformation creates its own rhythm in the work. Facial expression is the most important technique to master in all of character creation and illustration.

Tips & Pointers

NOTE
A close-up is used, focusing and intensifying the joy conveyed on the screen.

COMMENTS
With positive expressions, the eyebrows and mouth rise slightly; they typically turn downward to express negative feelings.

When drawing the mouth, be conscious of its three-dimensional aspects.

Include the teeth, to reinforce the emotional expression and add to the realism.

Wrinkles and smile lines enhance a facial expression, but use them with care.

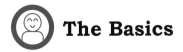 # The Basics

It's All in the Face

Joy, anger, enthusiasm, petulance: the most important elements of emotional expression reside in the face. As emotions are complex, there are endless possibilities and permutations.

 As shown in the figure on the right, even beginners can easily make facial expressions by shifting the eyebrows a little or express smiles by drawing a downward-arching mouth. But there are limits. No matter what, the expressions you choose need to make you character lifelike and appealing. If you combine facial expressions and poses, you can create more attractive emotional expressions.

Eyes and Eyebrows

The most important parts in creating facial expressions are the eyes and eyebrows. When you're trying to figure out or assess another's feelings, you look into his or her eyes. Also, remember to link the eyes and the surrounding facial muscles, so consider your eyes and eyebrows as coming in one set.

● Expressing Joy

When feeling mildly content, the eyelids and the muscles below will pinch the eyes and make them appear slightly thinner. The eyebrows lower or draw an arch above. With elation or extreme joy, the eyes widen, the white area of the eye expanding. The eyebrows rise and form an arch on top.

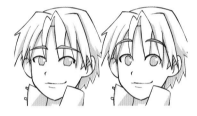

● Expressing Anger

Normal anger lowers the eyelids and lifts the eyes. The eyebrows assume a reverse figure eight. Open the character's eyes during intense anger and draw small pupils. Add wrinkles between the eyebrows.

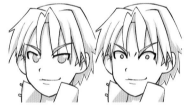

● Expressing Sadness

Normal sadness lowers the eyelids and the edges of the eyes. The eyebrows look like a figure eight. Extreme anguish is effective even if the eyes are wide open and the pupils are drawn and moistened.

● Expressing Humor

For a normal expression of humor, narrow the character's eyes with the eyelids and muscles under the eyes so that they're somewhat hidden. The eyebrows are slightly parallel and lifted. You can add some arches on the top. Open the character's eyes a little and arch the eyebrows.

The movement of the eyebrows and eyes is easier to convey if you draw them dynamically.

There's a way of drawing with closed eyes as well. For negative emotions (anger or sadness), draw an arch below the eyelid, and for positive emotions (joy or humor), draw an arch above.

Expressing Emotions with the Mouth

The shape of the mouth is also important for expression. The key to portraying the mouth is to raise the edges for positive expressions and lower them for negative expressions. Also, open the mouth up. With a closed mouth, emotional expression is limited.

● **Expressing Joy**

You can express joy even by closing the teeth and lifting the edges of the mouth. The greater the joy, the wider the character's mouth. The more you express your joy, the more your teeth show.

● **Expressing Anger**

The corners of the mouth fall and the character's teeth clench. If it's a fit of rage, the mouth opens wide. Showing the character's teeth will intensify the expression.

● **Expressing Sadness**

Lower the corners and clench the mouth to show regret, emphasizing the lower lip slightly. For sorrow, widen the corners of the mouth and open it wide. Slightly distort the outline of the mouth.

● **Expressing Humor**

In this case, a closed mouth also works; if it's opened, just not too much. Since it's a positive expression, it's a good idea to raise the character's mouth.

EXPERT TIPS ●●●

Drawing the Mouth

Draw the open mouth being conscious of the solid shapes present.

❶ Draw two U-shaped characters above and below. It's good to think that the joints of the mouth are like clamshells.

❷ Make an outline of the teeth.

❸ Draw the teeth and the tongue. If it doesn't look right, have only a few teeth showing.

Watch Out for Wrinkles

Wrinkles and facial folds are often a good way of emphasizing facial expressions. You can enhance the character's emotional expression by integrating the facial muscles. The wrinkles and contours that appear depend on

the facial expression. At the corners of the mouth, near the temples and eyes, between the eyebrows and on the forehead are just some of the locations.

It's important that the wrinkles between the eyebrows are blended with the eyebrows, the wrinkles at the corners of the mouth flow into the edges of the mouth, and that the wrinkles themselves are as inconspicuous as possible.

Of course, if you want to draw an old character or create a crazed, pinched expression, give wrinkles a try.

For the weathered, more furrowed face of an older person, add a range of wrinkle effects.

For a younger face, the two furrows on the inner sides of the eyebrows add a look of consternation or intense focus.

 # Take a Look: Practical Application

The client's request emphasizes the expression. In order to effectively depict both facial expressions and the surrounding scene, add a main character to a frame composition (page 62).

© James Togo

Flash Forward

Action and Motion

Battle, conquest, competition, motion poses bring the spark of life to your illustrations. Action elements can be used not only for fight scenes, but also for sports- and martial-arts-themed stories.

Tips & Pointers

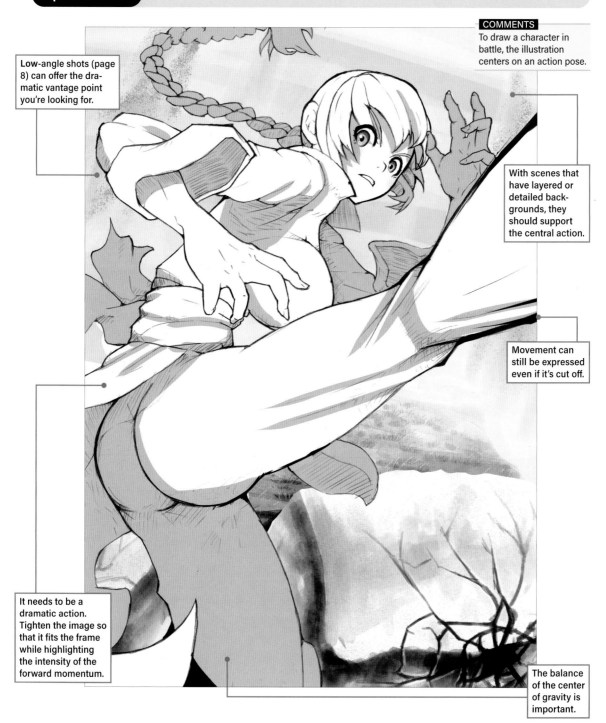

Low-angle shots (page 8) can offer the dramatic vantage point you're looking for.

COMMENTS
To draw a character in battle, the illustration centers on an action pose.

With scenes that have layered or detailed backgrounds, they should support the central action.

Movement can still be expressed even if it's cut off.

It needs to be a dramatic action. Tighten the image so that it fits the frame while highlighting the intensity of the forward momentum.

The balance of the center of gravity is important.

 # The Basics

Active Lives

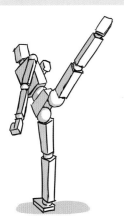

Knowledge of the joints and muscles is indispensable as a guide to designing effective action poses. For large, sweeping movements, the balance of the center of gravity is important. Watch videos of athletes if you find that helpful to better understand their stance and carriage. When drawing a specific action, it's important to draw a box, so that you can find the right fit. Try to display the illustrations frequently. Work horizontally in order to prevent drawing errors. If you look at it upside down or flip it left/right, it will be easier to find unexpected mistakes.

Try reversing the illustration frequently to prevent errors in the drawing or rendering. When you look upside down, unexpected perspective errors are easy to find and make it easier to remove the sense of incongruity.

Manga in Motion

Unlike with anime and games, it's difficult to create movement with a single illustration or image. In manga, you can assist movement with concentrated lines, but with color illustrations, they're harder to use, so use compositional models to assist you. Develop character poses with an awareness of flow, so try using diagonal line composition (page 42) or inverted triangle composition (page 30), and consider the background elements. Avoid details and motifs that may interfere with or obstruct the movement of your character, unless that's your deliberate intention.

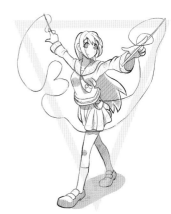

It takes some effort to create an inverted triangle composition, but when properly applied, it's very effective.

Removing Obstructions

Figure △ is an illustration of a runner, but there is an unnecessary line (the electric pole) in the background in the direction that the character's facing. If you leave it as is, it gives the impression that the object will collide with the character, and that it's hindered your character's movement. By removing the lines that seem to get in the way, the path is made clear. Think about the elements that will help but also about those that impede the flow and clarity of your image.

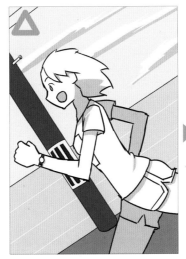

It looks like she's moving, but there's a thick, solid line in front of her, a utility pole, that obstructs the motion.

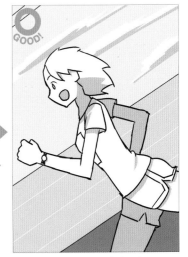

After the line is removed, the character looks more like she's running forward or downhill unimpeded.

The Power of the Pose

Choosing the Best Angle

Eventually you need to move beyond the staid, rigid, overly posed or stagey full-frontal view. Shifting the angle and cropping the image creates a sense of momentum. Low-angle and aerial shots increase the intensity and power of your illustration. As you progress to increasingly challenging—and interesting—angles and vantage points, use box-sketching techniques and your knowledge of muscles and anatomy to bring precision and realism to the pose.

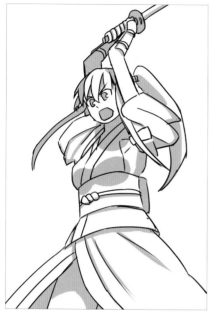

The low-angle view here adds a much-needed intensity. It also assumes the viewpoint of the person about to be attacked.

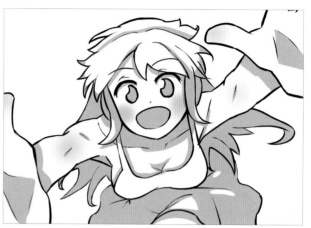

This angle captures the giddy heroine coming in for a hug. Actions need not be limited to battles and acts of aggression.

In the Middle of the Action

As you get increasingly familiar with action poses, try to expand the range of expressiveness you're able to capture. Choose the moment with the greatest impact, even if the angle presents a challenge. Some illustrators like to choose the moment during or after the clímax, but the leadup, the point just before the impact, can be even more effective.

From the moment ❶ when the punch is fully extended, ❷ pull it back to a point leading up to the blow being landed. Although it's less powerful and more difficult than choosing the point of impact, it's good to explore the range of options and the skills involved to bring it to the screen.

Posing the Action

Even if the center of gravity is balanced, action poses aren't always successful. Depending on the demands of the story, sometimes an off-balance composition, and the energy and momentum it introduces, is exactly what you're going for.

In the case of a fight pose like in the example, firmly locating the center of gravity will make the illustration look unnatural. The main character, vulnerable and about to be defeated, is off-balance and leaning back diagonally.

Movement can be expressed any number of ways, using not only poses but also composition, angles and overperspective (page 130).

 # Take a Look: Practical Applications

The complex pose is not in itself associated with a strong action, but the curved weapon and billowing smoke certainly set up the rest of the story.

© Tommy Walker, Inc. "Endbreaker!

Here the dramatically stagey pose requires precision and calculation, and a certain rigidity in the figure.

© Torigami Miyamax

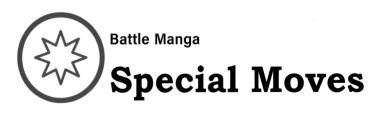

Battle Manga
Special Moves

A special move is an applied pose that draws in viewers, making a character stand out or highlighting an aspect of his or her personality. The content and context determine what techniques to use, whether it's a hand-to-hand martial arts throwdown or a fierce and slashing swordfight.

Tips & Pointers

Draw the trajectory of the sword to express a sense of momentum.

COMMENTS
Here it's not the point of impact that's shown but the moment leading up to it.

Use the entire screen, combining multiple poses and composition models.

The pose and motion need to match the character.

Here the effect is applied with an awareness of composition. Circle composition (page 38) is a good fit for the slashing action and the exaggerated emphasis on the main character.

Overperspective (page 130) would also be a strong addition here.

✲ The Basics

Break Out the Special Moves

For special moves, a few composition models are a strong fit: diagonal (page 22), inverted triangle (page 30) and diagonal line (page 42). Overlap (page 78) and the letter-based forms (page 66) also aid in coaxing out your character's individuality. Contrapposto (page 120) or S-shaped poses (page 124) that highlight and intensify the action are also good options. Just remember what's seemingly obvious: Make it easy to see and figure out what the character is doing. For a stand-alone illustration, you don't have the benefit of manga and anime's developing stories to provide the clarity and explanation required.

As for the pose, consider the action (page 154) and start the movement with the torque of contrapposto (page 120) or an S-shaped pose (page 124). For maximum impact, combine other compositions and poses as well.

In recent years, due to diversifying genres and consumer preferences, stories about magical young women have proliferated. Similarly, expressions are diversifying, and the use of overperspective has increased, so consider the whole range of compositional and design options available to you.

If you haven't planned out your illustration, effects that you add might appear haphazard or random.

Before, During and After

There are three stages or moments to focus on with a special move:

① Before the action's taken, weighing the options as emotions mount

② In the middle of the action, just before the blow lands

③ The aftermath, the roundhouse right has traveled its entire trajectory

The impression changes depending on the timing. Figuring out what you're going for in advance saves time and prevents the creation of visual confusion.

This is well-timed and well-balanced with a strong sense of momentum. The main character stands out as excessive effects haven't been used.

Using overperspective and other effects increases the difficulty and the time involved, but in the end you'll have a much stronger, more compelling illustration for it.

The follow-through as the technique is brought to its completion, a moment that's suitable to highlight for martial arts combatants.

The important thing is once you've chosen an approach, to get the timing right, stick with it. Since ② is difficult to draw, changing it to ① or ③ alters your intentions and yields unexpected results. If you must change course, draw the muscles using box sketching to get a sense of the adjustments you need to make.

Special Effects

The challenge is balancing composition with the effects you're trying to add. Often diagonal line composition (page 42) comes into play with radiating lines spreading across the illustration, a good reminder that the entire screen comes into play.

The main character helps form an inverted triangle (page 30) while diagonal composition (page 22) unifies the action and contributes to the sense of motion and flow.

A cross-diagonal effect is used here. In addition to triangular composition (page 26) overperspective is in play to generate more power from the limited range of the motion.

Because the character already comes bearing many details and visual elements, the image is powerful enough already without the need to layer on additional effects.

In addition to triangular and inverted triangular composition used on the main character, additional intensity is added throughthe low-angle perspective (page 8).

✺ Power of the Pose

Make a Move

Signature or special moves need not be dramatic or flashy. They do, however, need to be cleanly and clearly rendered and portrayed. As seen in the example, even the simple motion of turning the sword and the weapon's general trajectory as it slices through the air are enough for the illustration to have an impact. Here the protagonist stands out all the more through the combined use of Hinomaru composition (page 34) and circle composition (page 38).

✺ Take a Look: Practical Applications

This is drawn with the cut-in in mind. Even if effects aren't added, if the pose is uniquely defined, a signature move is born. Combine it with overperpective to intensify the image all the more.

© Student: RE

Here the muzzle is emphasized through overperspective, providing the illusion that it's being pointed or shot at the viewer.

© Adrenalize Co., Ltd. "Investigator Run Run"/Seiji Fujiwara

It's Magic

Fantasy Poses

It's not surprising that magical and enchanted poses are a key component of manga and anime. Just because fantasy or the supernatural are involved doesn't mean clarity shouldn't dictate the action. Plan ahead, finding a pose that matches the power or spell on display.

Tips & Pointers

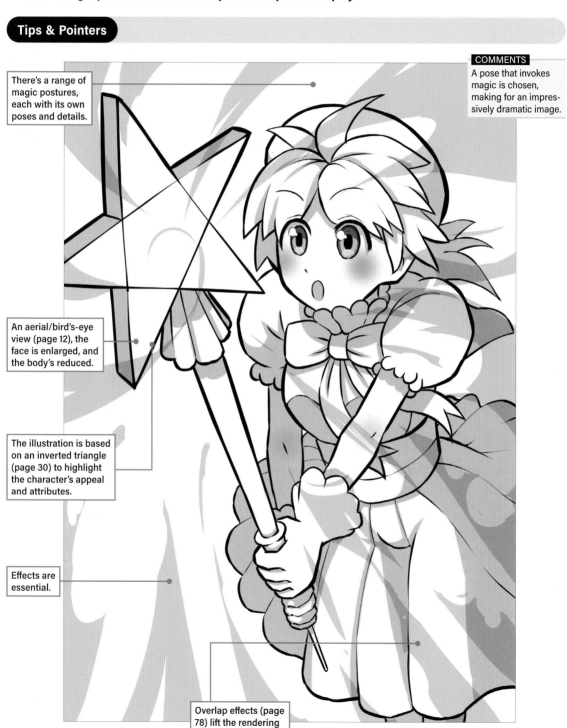

There's a range of magic postures, each with its own poses and details.

An aerial/bird's-eye view (page 12), the face is enlarged, and the body's reduced.

The illustration is based on an inverted triangle (page 30) to highlight the character's appeal and attributes.

Effects are essential.

Overlap effects (page 78) lift the rendering to the next level.

COMMENTS
A pose that invokes magic is chosen, making for an impressively dramatic image.

The Basics

The Mood for Magic

For scenes invoking magic, the most commonly seen compositions are triangle, inverted triangle, circle, diagonal and diagonal line. Contrapposto poses are also a strong addition, as are S-shaped poses for some witches, sorceresses and conjurers.

As an important element, magic triggers often start from the hands or wands, so if you place them in a striking arrangement or pose, the screen will appear more alive.

3 Types of Magic

There are three main types of magic-activation poses:
1 Invoking magical powers coupled with effects
2 Full-body pose often enhanced with the use of contrapposto
3 Relationship between two characters, one more powerfully posed

It is important to consider what type of pose you're drawing.

First of all, 1 isn't all that different from the examples looked at in the section on special moves (page 158), so refer to that discussion as well. Basically, the sense of momentum has been coupled with intense effects. Diagonal line composition (page 42) or diagonal composition (page 22) are two models to turn to here.

Let's draw the trigger scene 2 in a pose that's consciously "cute." Contrapposto (page 120) and the S-shaped pose (page 124) bring out the character's charms. Also, since it's a magically influenced scene, the movement of the hair and clothes can be ignored to some extent. Many of the effects are colored in a circular composition (page 38) to give a gentle impression, mainly using hearts and light.

Even if it's a battle scene, try to be too stylish or violent.

3 is special and very simple. You can express the magical by simply extending the finger or moving one end of the character's mouth. This approach is often seen in characters that keep secrets, like wizards.

Even with simple poses, with anime it's easier to capture magical action in a continuous scene; it's harder with these types of illustrations.

If it helps, draw the pose and the result or aftereffect on the same screen as shown in the figure on the right; or for clarity, use the frame layout (page 62).

Effects of Invoking Magic

With magic-themed scenes and elements, overlap is a common effect. Even if you don't apply it directly, it's also effective to enhance the sense of either reality or the suspension of disbelief you're going for.

Depending on the effect you want to highlight, try using low-angle views (page 8) and aerial/bird's-eye view shots (page 12). Refer to the circular composition (page 38) or diagonal composition (page 42) when considering the shape of the effect.

A common pose, the character twists around and looks back. The line of sight or gaze is guided to her eyes by adding an effect to that area.

The poses and effects are not necessarily flashy. The trick of the fireball effect is to draw an ambiguous shape, but have a general size in mind.

Extending one or both hands is a basic pose. Make clothes and hair flutter in the direction of the blowing wind for an added effect.

A fairly strong aerial/bird's-eye view shows the magical medallion in the sky. The magic circle, which is also synonymous with the invoking or activation of powers, is effective no matter how or where it's deployed.

 # Power of the Pose

Magical Triggers

To show individuality in your magically empowered characters, you might want to combine composition types for the greatest impact.

Lean on diagonal composition (page 22) or diagonal line composition (page 42) to lend your drawing the sleek sense of kinetic energy it needs. This approach also helps to heighten the impact by foregrounding the main element or defining motion you're trying to highlight in your character.

Play also with vantage points, perspective and angles until you find the ideal balance. While you're trying to present a dramatic and defined move to maximum effect, extreme close-ups aren't always the best way of achieving immediacy. Sometimes a little distance is needed to enhance the overall composition.

Even if it's a composite, don't apply the effect to the face. Draw blocks around the joints to create a believable line for the extended arm, then sharpen it to shape the image.

Take a Look: Practical Application

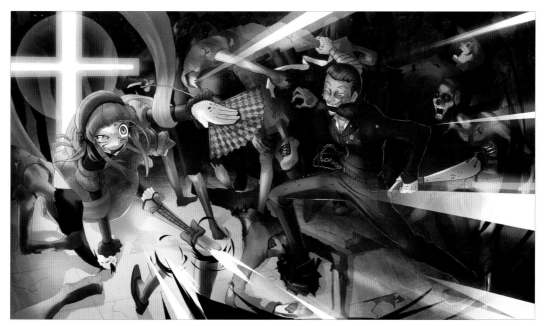

An illustration for a role-playing game. The character on the left is magically blowing away the zombies. It's drawn with the emphasis on creating a powerful and gripping scene, rather than a slick or cool image.

© Tommy Walker Inc. "Silver Rain"

Arm

● Draw the Arms

Using a box for the deltoid muscles on both shoulders, create a deltoid so as to draw an arch ❶. Extend the arms from there. Since the shape of the muscle group that stands out in the arm changes depending on the orientation of the palm, it's assumed that the hand is facing in even when the hand is not visible.

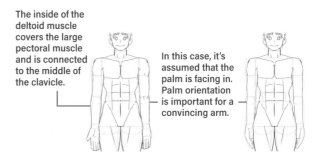

The inside of the deltoid muscle covers the large pectoral muscle and is connected to the middle of the clavicle.

In this case, it's assumed that the palm is facing in. Palm orientation is important for a convincing arm.

Box Sketching Muscles with an Aerial View

The aerial view of the face often makes the entire body visible from head to feet, so you need to know how to draw the entire body.

❶ Make a Box Sketch

Contrary to low-angle views, it's often difficult to see the neck along with the head. If you can't include the neck with the character's head, consider the distance so that there's a space between the head and the torso. The trapezius and clavicle may seen very little, if they're evident at all, depending on the position of the camera, but not as much as with low-angle shots.

With aerial view of the face, the top is large and the bottom's small. Try to get a good balance when you're at the box-sketching stage.

❷ Draw the Face and Neck

First draw the face and neck referring to how to draw an aerial view face (page 13). Next, divide the chest box into crosses and draw the pectoral muscles using the top two. If the collarbones or trapezius muscles aren't angular, make them so. Enlarge a little below the pectoral muscles, just not too much.

The large pectoral muscles and rectus abdominis muscles protrude in three dimensions. Be aware of the three-dimensionality for better muscle expression.

❸ Draw the Rectus Abdominis Muscle

In 7/10 of the divided lower box, squeeze in figure eights to make a sternum shape ❶. Next, draw a line in a figure eight to the lower box (pelvis), and make part of the pelvis protrude ❷. Once you've finished the pelvis, draw a line from the pectoral muscles to the crotch and draw a rectus abdominis muscle ❸.

Aiming at the end of the sternum, squeeze in figure eights until the beginning of the waist. Depending on the orientation one arm may be hidden.

The line is drawn down with a loose figure eight as an external abdominal oblique muscle to the pelvis. The pelvis is extended, and the line is drawn down with a figure eight again.

Draw a rectus abdominis muscle from below the pectoral muscles to the crotch.

④ Draw an Arm

Using the deltoid box on both shoulders, draw the deltoid like an arch. From there, lower the arms. The shape of the muscles changes depending on the direction of the palm.

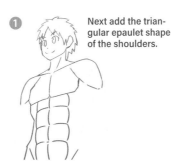

❶ Next add the triangular epaulet shape of the shoulders.

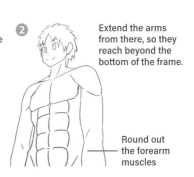

❷ Extend the arms from there, so they reach beyond the bottom of the frame.

Round out the forearm muscles

Full-Body View

Here it's helpful to take in the full-body view.

❶ Draw a Box

It's often difficult to see the neck because the head gets in the way. Consider the distance so that there's enough space between the head and torso. The trapezius and clavicle may not be able to be shown, depending on the position of the camera or viewer.

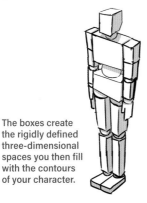

The boxes create the rigidly defined three-dimensional spaces you then fill with the contours of your character.

❷ Draw in Guide Lines

They will help with the placement of the pectorals. Then add in the collar of muscle that encircles the neck.

Laying down the crisscrossing lines helps you calibrate the width and bulk of the upper torso.

❸ Draw the Rectus Abdominal Muscle

On the left side of the lower box, squeeze in the shape of an inverted figure to indicate the outline of the sternu ❶. Next draw a line in the shape of a figure eight to the lower box to make the pelvis protrude ❷. Once you have the pelvis, draw a line down from your pectoralis major to the crotch and draw the rectus abdominis ❸.

❶ The line should be placed at roughly where the 7 is located on a clock face.

❷ The line snakes around to define and shape the abdominals and stomach area.

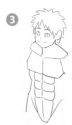

❸ Finally, it's time to add in the six pack, much easier to achieve onscreen than in reality!

169

❹ Draw the Legs

The aerial view yields a line of sight that's compressed downward. So, as the vantage descends, draw smaller and shorter ❶. It's easy to draw if you consider each part independently, such as thighs, knees, calves and feet ❷ ❸.

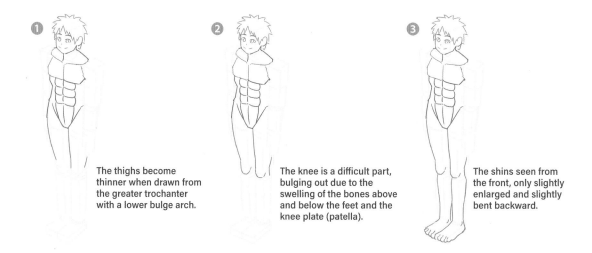

The thighs become thinner when drawn from the greater trochanter with a lower bulge arch.

The knee is a difficult part, bulging out due to the swelling of the bones above and below the feet and the knee plate (patella).

The shins seen from the front, only slightly enlarged and slightly bent backward.

❺ Draw the Arms

Using a box for the deltoid muscle, draw a triangulated line ❶ like an arch, and then extend the arm ❷. Even if you can't see the hand, as in many low-angle shots, figure out the orientation of the palm.

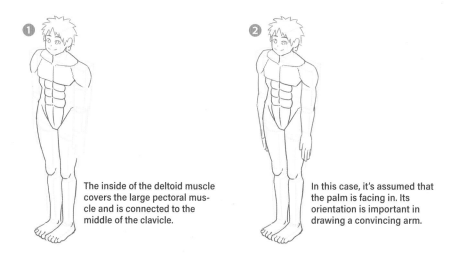

The inside of the deltoid muscle covers the large pectoral muscle and is connected to the middle of the clavicle.

In this case, it's assumed that the palm is facing in. Its orientation is important in drawing a convincing arm.

CAUTION!

Aerial/bird's-eye view and low-angle box sketching can of course be used for both male and female characters. However, when drawing a female character, the breasts are larger and the hips are wider and more rounded. It's important to draw the waist slightly higher than on men and the waist, wrists and ankles should be thin and tapered.

How to Create Data

When you draw an illustration, do you have any questions about the canvas size and resolution?
When presenting on the Web, it's fine for the originals to be any size you like, but there are some elements that you need to be aware of when creating printed materials such as posters and booklets or drawing an illustration on commission.

Paper Size

There are various standards for the vertical and horizontal ratio of the paper, but the most familiar ratio is called A row and B row. It's easy to understand if you think of A4- or B4-sized paper.

Both A row and B row have an original paper size of A0 and B0, and the one cut from it is sized to A1 or B1 and further cut from that in half. In this way, the numbers attached to A and B increase each time it's cut in half.

● Size of Columns A and B

A0	841mm×1189mm	B0	1030mm×1456mm
A1	594mm×841mm	B1	728mm×1030mm
A2	420mm×594mm	B2	515mm×728mm
A3	420mm×594mm	B3	364mm×515mm
A4	210mm×297mm	B4	257mm×364mm
A5	148mm×210mm	B5	182mm×257mm
A6	105mm×148mm	B6	128mm×182mm
A7	74mm×105mm	B7	91mm×128mm
A8	52mm×74mm	B8	64mm×91mm
A9	37mm×52mm	B9	45mm×64mm
A10	26mm×37mm	B10	32mm×45mm

Both A and B columns have a side length of 1: $\sqrt{2}$ (1: 1.414), which is considered "beautiful" according to the concept of the golden ratio discussed in the first section.

POINT!

Remember that column B is larger than column A, even for the same number.

A3, A4, B4 and B5 are commonly used paper sizes for both professional and personal use, so it's useful to remember the numbers.

Resolution

Resolution is just as important as paper size. Generally expressed in units of dots per inch. Both the display screen and the printed one show the image as a collection of dots. Therefore, the more points in the same range, the wider the range of detail, expression and clarity.

low resolution high resolution

The above is the same A4 size with the same circle, but the left with the lower resolution is rougher than the right with its higher resolution.

● **Appropriate Resolution**

The higher the resolution, the sharper, crisper and more eye-catching the image will be.

If the resolution exceeds a certain line, the human eye will hardly notice the difference. When displaying on the Web without printing the image, 72 to 96 dpi should be sufficient. However, when it comes to printing hard copy, high resolution is required. Generally,

Color printing resolution	**300-350 dpi level**
Monochrome printing resolution	**600-1200 dpi level**

color works require 300 to 350 dpi. Monochrome works are even more expensive and require 600 to 1200 dpi. The reason why monochrome requires such high resolution is that monochrome is actually two gradations expressed in two colors, white and black. So increase the resolution.

Note that even if the image is drawn at a lower resolution and the resolution is increased by software functions, there's no added effect. Make sure to set the resolution first.

Bleeding

When printing a work without a border, you need to be aware of what's called bleeding.

Many printers for home use can produce work without borders, but in proofs generated professionally at a print shop, print on paper that's slightly larger than the actual finished size, then cut it.

The black marks in the four corners are dragonflies. The red line will be trimmed to the final size. (The red line is just included for clarity, so never put one on an actual illustration.)

For this reason, crop marks called dragonfly marks or trim marks are placed at the four corners of the document, and the machine cuts them using them as a guide.

● Two Ways to Create Bleeds

One way is to draw a work the exact size of the finish and use a dragonfly to enlarge the manuscript slightly. In this case, you have to keep an eye on the parts lost by cutting.

The other one is to draw a work with a size 0.2 inches (3 mm) larger than the finished size, up, down, left and right. For example, if the finished size is 8.25 by 11.75 incghes (210 mm x 297 mm) with A4, add 3mm above and below to draw 8.5 by 12 inches (216 mm x 303 mm).

By cutting the edges, you can anticipate in advance the range the work will lose, for a stronger, sharper finish.

The dragonfly at the upper right of the above image is enlarged.

Add at least 0.2 inches (3 mm) to all sides. The mark can be longer than that, but it must be placed on the top layer so that it's not hidden.

Gutters and Margins

When drawing works for books and magazines, it's important to be aware of the page structure.

● **Gutter**
Refers to the center of the book when it's opened, where the publication is bound.

● **External margins**
There are the parts that run along the outer edges of the spread.

● **Sky**
Refers to the top of the book.

● **Ground**
Refers to the bottom of the book.

Sky

external margin gutter external margin

Ground

When drawing a page-related work, it's the gutter that you have to pay particular attention to because this is the area where the binding is. Therefore, avoid placing important elements such as the character's face there. The same applies when drawing on either the left or right page, or when creating two-page spreads.

Gutter Side

If you draw an important element such as a face near the gutter, it will become obscured or lost.

Unlike the gutter, the external margins are not bound and hidden, so you don't have to be as attentive of them. Still avoid placing important elements in that area as well. Part of the work may be hidden by the reader's finger.

In the case of illustrations in commercial magazines, you often know which work will be assigned to the left or right page due to production templates. In this case, choose a composition in which important elements are not placed in either flank.

Choose a composition that allows a certain amount of margin so that either the left or right side can be cropped or expanded.

Index

Action poses, 25, 123, 148, 154-157, 159
Aerial/bird's eye view, 12-15, 20, 21, 33, 37, 63, 79, 89, 108, 116, 148, 156, 163, 164, 170
Alphabet compositions, 17, 21, 66-69, 71, 104, 107, 135, 144, 159
Anatomy, human, 9, 13, 128-129, 131, 147, 148, 152, 155, 156, 166-170

Bleeding, 173
Blurred effects, 79, 118
Box sketching, 9, 12, 15, 122, 131, 143, 165, 166, 168, 169

Center of gravity, 138-141
Chibi-style illustrations, 133, 142
Circle compositions, 38-41, 45, 87, 108, 115, 116, 117, 135, 144, 148, 158, 161, 163, 164
Close-ups, 17, 86-89, 90, 91, 95, 96, 97, 112, 150
Contrapposto, 97, 98, 104, 120-123, 127, 159, 163
Cropping, 82-85, 101

Data creation, 83, 171-175
Diagonal compositions, 19, 22-25, 45, 47, 69, 108, 159, 160, 163, 164
Diagonal line compositions, 19, 42-45, 47, 63, 80, 83, 107, 116, 126, 148, 155, 160, 163

Emotions, 64, 146-149, 150, 151, 152
Expert tips, 6, 24, 29, 36, 40, 44, 49, 52, 60, 72, 80, 128-129, 131, 137, 140, 152
Eye level, 20-23, 49

Facial expressions, 64, 86-89, 91, 92, 135, 147, 149, 150-153
Foreword, 5
Frame compositions, 36, 58-61, 64, 113, 116, 153, 163
Full-body shots, 17, 102-105, 112

Golden ratio, 74-77
Group shots, 15, 17, 65, 113, 114-117, 145
Gutenberg diagram, 71, 73

Hair and clothing, 95, 96, 100, 110, 135, 142-145, 146, 147, 148, 149
Hinomaru compositions, 17, 18, 34-37, 39, 43, 45, 54, 56, 59, 64, 66, 72, 83, 105, 108, 161

Inverted triangle compositions, 13, 17, 30-33, 41, 67, 69, 104, 108, 110, 112, 114, 116, 117, 144, 155, 159, 160, 162, 163

Low-angle shots, 8-11, 89, 90, 93, 105, 108, 112, 148, 154, 156, 160, 164, 170

Magic-related effects, 25, 93, 162-165
Margin compositions, 33, 52, 54-57, 59, 64, 78, 83, 110, 116, 148
Medium close-ups, 17, 85, 90-93, 94, 95, 96, 97, 98, 112, 147
Medium long shots, 17, 85, 97, 98-101, 112
Medium shots, 17, 91, 94-97, 112

Objects, 18-21, 90
Overlap compositions, 18, 19, 65, 68, 78-81, 107, 109, 116, 159, 162
Overpass compositions, 93, 101, 130
Overperspective, 104, 105, 108, 113, 130-133, 148, 157, 158

Panel compositions, 17, 62-65

Range of motion, 128-129
Reader's guide, 6
Resolution, 172

Silhouettes, 134-137
Special moves, 25, 158-161, 163

Split compositions, 46-49
S-shaped compositions, 21, 34, 41, 98, 99, 123, 124-127, 159, 163
Symmetry compositions, 46, 48, 49, 88, 107, 108

Three-part compositions, 17, 19, 42, 50-53, 56, 64, 69, 72, 74, 75, 104, 108, 112
Three shots, 17, 110-113
Tilting, 8, 9, 10, 11, 15, 21, 24, 80, 83, 85
Triangle compositions, 9, 17, 26-29, 41, 67, 78, 90, 95, 102, 104, 105, 108, 111, 112, 116, 117, 132, 135, 141, 160, 163
Two-part compositions, 19, 42, 46-49, 50, 56, 108
Two shots, 8, 17, 106-109

X compositions, 107, 108

Y-balance, 138

Z compositions, 17, 52, 70-73, 65, 66, 70-73, 104, 115, 116, 117

Published by Tuttle Publishing, an imprint of
Periplus Editions (HK) Ltd.

www.tuttlepublishing.com

Digital Illust no Kozu, Pose Jiten
Copyright © 2017 Shikata Shiyomi
English Translation rights arranged with SB Creative Corp.
Through Japan UNI Agency, Inc., Tokyo

English Translation Copyright © 2020
Periplus Editions (HK) Ltd.

Library of Congress Cataloging-in-Publication Data is in
process

ISBN 978-4-8053-1564-4

All rights reserved. No part of this publication may be
reproduced or utilized in any form or by any means,
electronic or mechanical, including photocopying,
recording, or by any information storage and retrieval
system, without prior written permission from the publisher.

Distributed by
North America, Latin America & Europe
Tuttle Publishing
364 Innovation Drive
North Clarendon, VT 05759-9436 U.S.A.
Tel: 1 (802) 773-8930; Fax: 1 (802) 773-6993
info@tuttlepublishing.com
www.tuttlepublishing.com

Japan
Tuttle Publishing
Yaekari Building 3rd Floor
5-4-12 Osaki
Shinagawa-ku
Tokyo 141 0032
Tel: (81) 3 5437-0171; Fax: (81) 3 5437-0755
sales@tuttle.co.jp
www.tuttle.co.jp

Asia Pacific
Berkeley Books Pte. Ltd.
3 Kallang Sector #04-01
Singapore 349278
Tel: (65) 6741-2178; Fax: (65) 6741-2179
inquiries@periplus.com.sg
www.tuttlepublishing.com

25 24 23 22 10 9 8 7 6 5 4 3

Printed in China 2209EP

TUTTLE PUBLISHING® is a registered trademark of
Tuttle Publishing, a division of Periplus Editions (HK) Ltd.

Books to Span the East and West

Tuttle Publishing was founded in 1832 in the small New England town of Rutland, Vermont [USA]. Our core values remain as strong today as they were then—to publish best-in-class books which bring people together one page at a time. In 1948, we established a publishing office in Japan—and Tuttle is now a leader in publishing English-language books about the arts, languages and cultures of Asia. The world has become a much smaller place today and Asia's economic and cultural influence has grown. Yet the need for meaningful dialogue and information about this diverse region has never been greater. Over the past seven decades, Tuttle has published thousands of books on subjects ranging from martial arts and paper crafts to language learning and literature—and our talented authors, illustrators, designers and photographers have won many prestigious awards. We welcome you to explore the wealth of information available on Asia at **www.tuttlepublishing.com**.